CONNECTICUT VALLEY TOBACCO

Enjoy!

CONNECTICUT VALLEY TOBACCO

BRIANNA E. DUNLAP | *Photography by Leonard Hellerman*

Published by The History Press
Charleston, SC
www.historypress.net

Copyright © 2016 by Brianna Dunlap
All rights reserved

Photography by Leonard Hellerman

First published 2016

Manufactured in the United States

ISBN 978.1.46713.613.6

Library of Congress Control Number: 2016939306

Notice: The information in this book is true and complete to the best of our knowledge. It is offered without guarantee on the part of the author or The History Press. The author and The History Press disclaim all liability in connection with the use of this book.

All rights reserved. No part of this book may be reproduced or transmitted in any form whatsoever without prior written permission from the publisher except in the case of brief quotations embodied in critical articles and reviews.

For the Valley, its people and its beauty.

CONTENTS

Acknowledgements 9
Introduction 11

1. Native Tobacco, Appropriation and the Motherland:
 Early Woodlands Era–1600s 15
 Day Trip Location: The Institute for American Indian Studies

2. Colonial Connecticut River Valley: 1630s–1790s 20
 Day Trip Location: The Windsor Historical Society

3. More Guns, More Tobacco: The 1800s 29
 Day Trip Location: The Southwick History Museum

4. The Peak Years: 1880s–1930s 39
 Day Trip Location: Salmon Brook Historical Society

5. Summer Camp Adventures and Civil Rights Roots: 1940s–1950s 61
 Day Trip Location: The Connecticut Valley Tobacco Museum

6. Changing Times: 1960s–1970s 76
 Day Trip Location: The Wood Memorial Library

Contents

7. The Nineties Boost: 1980s–1990s Day Trip Location: Historic Deerfield	90
8. Cuba Reopens: 2000s–2010s Day Trip Location: Suffield Historical Society	95
9. Living Legacy in the Valley: Preserving Tobacco History Day Trip Location: Brown's Harvest	104
Notes	113
Index	125
About the Author	127

ACKNOWLEDGEMENTS

This book would not have the same impact without the stunning photography that you will see in these pages. The photographer who has contributed these tobacco images is Dr. Leonard Hellerman. Hellerman, a native of Windsor, Connecticut, has used photography as means of artistic expression for most of his life.

Hellerman has contributed to several books in which his photography graces the cover of the book as well as the interior. His photographs are found far and wide, including two permanent museum displays, at the New Britain Museum of American Art and in the permanent collection of the William Benton Museum of Art of the University of Connecticut, at Storrs.

I first got to know him better in 2014 when he and his wife attended the Fourth Annual Cigar BBQ at the Connecticut Valley Tobacco Museum. The event had sold out, so we had to utilize a transport van to shuttle attendees between the museum and the tobacco farm since the bus we rented for the event was packed. I unexpectedly found myself driving the van and its six passengers to the Habana tobacco fields in Enfield, Connecticut. We were all chatting on the way to the farm, and Mr. Hellerman asked me, "So, how did you get into this?" and I, never one to miss an opportunity for a quip, said, "Well, Leonard, I've always wanted to drive a van." We all had a good laugh and everyone got to share a bit about why they loved tobacco or cigars.

Since then, I've come to know that Hellerman has prestige and pride in his art. And it truly is that—art. As I began this book, he was kind enough to have me visit his home studio. His wife made me tea and cookies while he

Acknowledgements

toured me through his extensive collection of tobacco agricultural images. In these pages, you will find photographs of tobacco, its people and its landscape. Each image by Leonard Hellerman has been crafted just for you, the readers and lovers of the Connecticut River Valley's cigar tobacco heritage.

The following people have my deepest gratitude: Dr. Leah Glaser, head of the Public History Program at Central Connecticut State University, for her support, time and caring; thanks to Lucianne Lavin of the Institute for American Indian Studies for information on early tobacco use and spirituality. A big thank-you also goes to the research experts who are the knights in shining armor of the historian world: Pat Odiorne from the Southwick Historical Society, Claire E. Lobdell at the Wood Memorial Library and Museum, Michelle Tom at the Windsor Historical Society and David Bosse at Historic Deerfield. Thanks to Kimberly Reeger for her insight into cigars and women.

I'd like to thank the board of directors of the Connecticut Valley Tobacco Historical Society exponentially!

And, thank you Jason—for everything that words cannot possibly summarize.

INTRODUCTION

From the glory years of tobacco in the Connecticut Valley through the challenges of modern farming, the reader will know who shaped the history here and why the tobacco industry had influence and was also influenced by the global economy. This brief book will cover the full spectrum of Colonial Connecticut's cigar tobacco history, and each chapter will engage the public with a day trip to a tobacco-related site, making the entire narrative a source of history and as well as a driving tour.

The history will begin broadly, beginning with the earliest North American tobacco usage and the techniques used by native people in Connecticut for cultivation and consumption. The colonial era, as related to tobacco economy, will be delved into. The stories will include the initial successes in Jamestown, Virginia, and how tobacco became America's first successful crop. Returning to Colonial Connecticut, the myths of Revolutionary War hero Colonial Putnam and cigar roller Sally Prout will be explored. From the boom of the 1860s to the glory days of the 1950s, the fall of popularity of tobacco in the 1960s through the resurgence of cigars in the 1990s and the reopening of Cuba in 2015, the tobacco industry will be explained in an engaging and relatable way.

The ultimate hope with this book is that you, the history enthusiasts, will enjoy learning of the hundreds of years of Connecticut River Valley tobacco agriculture and explore the back roads of the Valley with the included driving-tour destination in each chapter. Make a day trip out of visiting the sites in this book and feel empowered by being part of a living legacy in the Tobacco

Introduction

Valley. With this driving-tour component, you will build connections between the history and the important region that they are a part of.

As well as enjoying a connection to the landscape, many readers in the Connecticut River Valley have made tobacco a part of their personal history from working tobacco in their youth. Enjoy the spots across the same valley that will help them remember that past and think about the future.

The driving tour locations are set up to be experienced as day trips. While it is possible to fit in a few locations in one day, it is recommended that each spot be visited one at a time to allow for ample adventure and learning time. The locations found at the end of each chapter sometimes correlate directly to the subject of the chapter; sometimes they do not. The roads to every location will take you through gorgeous landscapes right to the sites of significant cigar tobacco history. Do not forget, the sites are family friendly.

Enjoy the history in these pages and out in the Valley!

Summer Break

*Before the sun rose
and the mists burned off
we stood around in jean jackets
and work boots, smoking
Luckies and dreaming of Camaros.
And when it was time
we got down in the dark furrows
of earth—still clotted with pools
of irrigation water—
between rows of tobacco,
snapping suckers
and gathering mounds
of own our native soil—
soil of our parents
and our parents' parents—
pumped up from the Farmington
and the Connecticut, cool and black
and crumbly, around and gentle
stalks.
By July the plants grew tall
and we came through the rows, crab-like,
standing by degrees.
And each day the soil baked and broke
and got stuck in everything
and came swirling off in a fine powder
when we slapped our thighs.
But under the nets we picked and
piled the leaves, threw dirt,
cursed, fought, dodged the sadistic straw boss
and dreamed of girls,
sweet and horny and out of reach.
Like ants plundering a grave
we worked feverishly, stripping the fields
and filling the sheds, stopping only at the end
of a row for a drink or to gaze
at the dusty trees lining the river*

(which wafted up to us, shad-smelling,
muck-funky, sweet)
and beyond—the blue sky
vague and unformulated
like a thought of somewhere else,
before plunging in again. We did this
and got paid. And the summer grew on and on
arching over our heads like a golden bubble.
By autumn—the tobacco picked
and hung and fired
syrupy brown—
we were already gone,
pursuing thoughts of distant cities
and loves. But for a whole season
we sweat and troubled
through the ancient valley,
caked with mud and resin
from the soles of our shoes
to our hair, black and burned
and exhausted and happy.

Nicholas Fillmore Jr.
Windsor, Connecticut

1

NATIVE TOBACCO, APPROPRIATION AND THE MOTHERLAND

EARLY WOODLANDS ERA–1600S

Tobacco has been as much a part of the landscape of New England as the oak trees and the endless stones that made the famous walls that contour the earth like veins of the soil. The Native Americans of the region used carefully cultivated tobacco with regularity and purpose. This chapter will briefly touch on the use of tobacco by the Native American peoples of this region from the Adena period, roughly 1000–200 BC. This lengthy era is also known as the Early Woodland Period.[1] The so-called "Eastern Woodland tribes" were not a single race but tribes with varying lives, language and agricultural practices. Their oral tradition means that no written records remain to tell modern people about their lives from their point of view of the thousands of years when this was their land; however, what modern Native Americans in New England and historians know comes from continued traditions, traveling journals of European explorers or from methodical records kept by colonial missionaries.

Cigar tobacco grown in the Connecticut River Valley today is not at all like the tobacco that was introduced to the North American continent sometime in the first millennium. The movement of the tobacco plant followed migration of peoples to the American Southwest via Mexico then on to the Great Plains and eventually the Eastern woodlands.[2] The most widespread form of tobacco in the northeast was *Nicotiana rustica*, a

descendent of the very plants that migrants brought up through the Central and North American continents from its South American origins.

The earliest practices of smoking tobacco, as well as smudging, are less understood than we would like. Scholars do not agree about when tobacco became a part of Eastern Woodland traditions.[3] Yet the traditions that have morphed through generations still carry on in modern native cultural practice. Some evidence of early tobacco use comes from a study of residue of pipes found at the Boucher Site in Vermont. The pipes were made during the Early Woodland Period,[4] and their residue proves *Nicotiana rustica* was definitely used by the native peoples of the Eastern Woodlands long before *and* at the time of contact with colonizers from Europe.

Nicotiana rustica, which has the highest concentration of nicotine of the natural *Nicotiana* species,[5] indicates that native users knew that tobacco would make them experience a psychoactive effect. This use of tobacco in the Vermont area goes as far back as 500 or even 715 BC. There is not enough evidence to determine whether the tobacco people used in pipes was wild or domesticated. But if it was domesticated at that early time, some have suggested that the very act of raising tobacco on purpose for regular use may have had as much ceremony to it as the actual act of smoking.[6] Oral history offers some clues. In the New England region alone, many stories have been passed down through generations to explain the birth of tobacco into tribal lives. They suggest that "one derived it from the grave of a venerated squaw, one attributes it to the sacrificing of a beautiful young princess to bring famine to an end, and one tells of its theft from a grasshopper" by a hero.[7]

The Pequot, the Iroquois, the Algonquian, the Mohegan and the river tribes that resided up the shores of the Connecticut and into Massachusetts, Vermont, New Hampshire and Maine knew of the tobacco plant. For the Eastern Woodland Native Americans, this was a plant with both medicinal and spiritual properties. In most tribes, the men would have the traditional role of growing the weed. Smoking was of particular use in political meetings, where the smoke itself "was thought to be pleasing to the deities, whose presence at the meetings were sought in order that they might help indigenous leaders in the decision-making process."[8]

In 1492, Columbus landed in the Bahamas. The land, of course, was already the home to nations and tribes that had lived in their own cultures for millennia. These inhabitants offered tobacco to the Europeans who landed on their shores. Europeans understood little about it, only that the leaves were valuable enough to be bartered for.[9]

The dates vary in accounts of when Europeans brought tobacco over to the European motherlands. Regardless, samples of this new and exciting plant were sent from the American continent to Europe beginning about the 1550s; subjects of the various European crowns would send samples of tobacco to their respective royals. In 1558, Jean Nicot, the French ambassador to Portugal, sent seeds to his sponsor Catherine de' Medici. To commemorate the services of Nicot, the plant was given the generic name that we are familiar with, *Nicotiana*.

Multiple dates and people can be credited with tobacco "firsts," such as mariners traveling from Peru in 1585 or explorer Ralph Lane from Virginia.[10] According to later seventeenth-century records, Englishman Sir John Hawkins first brought tobacco to England in 1565, but the English did not immediately embrace it.[11] The taking of tobacco in England for personal use was first documented in 1590, but that may indicate that it was being used before it was being written about.[12] Snuff tobacco, or the taking of tobacco by placing it in the nose to have the nicotine absorbed by the tissue, became a fad that even women of the upper classes took part in.[13] Smoking and using snuff became popular and hated by opposing mindsets, but one thing was clear—tobacco was only gaining in popularity.

By 1600, eager explorers began crawling up and down the shores of their "New World." In their journals, they documented the tobacco use of the Eastern Woodlands native peoples. One such European was English captain George Weymouth, who sailed the coast of Maine in 1605. In June of that year, he wrote that he saw tobacco plants being grown by the Native Americans that were only about a foot above the ground. The natives who he and his crew traveled with used sign language in order to communicate that the knee-high plants they saw would grow to be a few feet tall and produce leaves that would be as "broad as both their hands."[14]

Why did Native Americans partake in tobacco? We know that in Maine in the 1660s, native men of the Piscataqua region would relax themselves with a stone tobacco pipe carved with images, then nap before the women served dinner.[15, 16] The natives whom Puritan Roger Williams met with said that they took it for two practical reasons. First of all, it fought "against rheum, which causeth the toothake, which they are impatient of; secondly, to revive and refresh them, they taking nothing but water."[17] In other words, they utilized tobacco as an appetite suppressant. Colonists reported that the men of the tribes would almost always have a bag with tobacco and a pipe on them.[18] Some tribes, particularly some of the Algonquians, may have opted to chew tobacco, although this was not the norm in the Eastern

Woodlands.[19] Whether for pipes or chew, there are native words for the strength of tobacco, such as *wuttammauog*, which means weak tobacco.[20]

Tobacco had many names among native peoples. English traveler John Josselyn, who recorded tobacco use and cultivation during his two voyages to New England between 1638 and 1663, noted that some call it *petum* or *petum nicotian*, which is a blending of the native word *petum* and the scientific name given to the plant in the 1550s. Josselyn wrote, almost in awe, that at the time no other commodity was as engaging to the public as tobacco. It added a special something as a complement to entertainment while simultaneously chaining its users to a habitual use.[21]

There were three types of tobacco that native people blended for use, but they did not plant the crop extensively. In fact, European travelers like Josselyn and colonists who came into the lands of the Native Americans commented that the natives had not "learned the right way of cultivating" tobacco, as if they were vastly more knowledgeable in growing a crop Native Americans had been growing for thousands of years.[22] For the invaders of the land, perhaps the fact that the tobacco was not being grown for mass use was a concept that they could not fit into their own cultural norms.

Here is an excellent time to introduce the basics of native New England–style tobacco cultivation. In April, native peoples prepared a rich bed of earth, about nine feet by four feet, on which they would throw a thick layer of seed. They stamped down hard on this seeded bed with their feet, cast down more soil on the bed and then stamped it down once again. When the seedlings had grown enough to have four or more leaves, they removed the small plants from this protected bed and replanted them in a larger field for the rest of the growing period. When the flowers of the tobacco plant begin to bud, planters would snap the flower off.[23]

Josselyn gave a lengthy list of the uses and virtues of *poke*, the name of a small round-leafed tobacco that the Native Americans he encountered in Northern New England grew.

> *It is odious to the English. The vertues of Tobacco are these, it helps digestion, the Gout, the Tooth-ache, prevents infection by scents, it heats the cold, and cools them the sweat, feedeth the hungry, spent spirits restoreth, purgeth the stomach, killeth nits and lice; the juice of the green leaf healeth green wounds, although poisoned; the Syrup for many diseases, the smoak for the Phthisck, cough of the lunges, distillations of the Rheume, and all diseases of a cold and moist caugh, good for all diseases of a cold and moist caufe taken upon an empty stomach, taken upon a full stomach it*

precipitates digestion, immoderately taken it dryeth the body, enflameth the blood, hurteth the brain, weakens the eyes and sinews.[24]

To the Native Americans and the colonists who began to use tobacco, this description describes the plant as a heal-all that was cultivated with care. If the user was an infrequent partaker, however, its use could lead to a negative effect to the body and mind. In modern Eastern Woodland nations, tobacco is still considered a sacred and medicinal plant and used to purify individuals during ceremonies or festivals. The Schaghticoke, a nation in northwestern Connecticut,[25] blended a variety of plants such as wild lobelia, herbs, barks and roots, including red willow, which is still found in "Indian" tobacco today.[26]

To explore Eastern Woodlands Native American tobacco history in person, check out:

The Institute for American Indian Studies
38 Curtis Road
Washington, CT 06793
Hours: Monday through Saturday 10:00 a.m. – 5:00 p.m.
Sunday 12:00 p.m. – 5:00 p.m.
(860) 868-1649

Find out more at www.iaismuseum.org

2
COLONIAL CONNECTICUT RIVER VALLEY

1630s–1790s

Colonial New England was not a simple place. The diverse tribes who experienced the arrival of the colonists in America engaged with the new inhabitants of the land in harmony and disharmony. They experienced cultural appropriation and eventually fought to protect their lifestyles in wars such as the Pequot Wars and King Phillip's War. The Anglo settlers and the African slaves that they brought with them into the Native American lands may have lived with homes and farming that modern people view as quaint, but the people who inhabited the land still experienced the drama, love, fights, drive for righteousness and tastes that are experienced today. The taste, or distaste, for tobacco began long before English colonizers came to Massachusetts and Connecticut.

The first insult in the English language about tobacco users emerged in 1602. In London, it was deemed by one anti-tobacco proponent as comparable to the work of chimney sweepers. This may seem like an odd or soft insult, but it was meant to be a harsh critique of social smokers. Smoking would "make their brains sooty and admit that they had accepted the devil."[27] Insults to tobacco users did almost nothing to slow its spread in popularity in Europe, and certainly not in the colonies of North America.

Virginia's tobacco cultivation was crucial to the economic success of the flagship colony. In fact, historians have argued that tobacco saved Jamestown, Virginia, from becoming a failed colony. The English who lived in that settlement did not have a good start, by anyone's interpretation. A wave of

an additional three hundred colonists carrying disease and adding to the food demand set foot on shore in the late summer of 1609. The neediness of the invading English pressed the Powhatan people's patience and their own food resources. The Powhatans attacked Jamestown in the First Anglo-Powhatan War and left colonists on their own for the winter. During this time, 80 percent of the colony did not survive.[28] The living standards there deteriorated to the point that the English colonists resorted to cannibalism in the winter of 1609.[29]

Years later, tobacco cultivation helped change everything in Jamestown. In 1612, John Rolfe, the husband to the Powhatan woman made famous by colonist John Smith's diaries, Pocahontas, was the first known colonist to grow tobacco. He learned how to cultivate it from the knowledge that Pocahontas provided. By 1617, the settlers of Jamestown, Virginia, were growing tobacco on every piece of land that they could spare. Just two years later, about twenty thousand pounds of tobacco leaf were shipped to England. King James I despised the leaf, but his subjects loved it so much that some accounts claim that in 1620 young women were happily paid in tobacco to be shipped to the New World to be wives of tobacco farmers. The beginning of a trade in a valuable commodity had begun.[30]

The Virginia Company sought to regulate the growth of the plant in 1620 because planters would focus on raising tobacco for profit instead of broadening their agricultural horizons. The major players in the trade company disliked the plant but soon begrudgingly accepted that the crop would have a staying power in the colony.[31] The conflicting attitudes toward tobacco are constant elements in its history since its appropriation during the American colonization period and onward.

Making the tobacco trade even more controversial was its close association with slavery. In the colony, then state, of Virginia, captive Africans were held as slaves to raise the crop that kept growing in demand and value. In 1617, colonists realized that tobacco would cure, or age slowly in the air, if it were hung instead of remaining in piles on the ground to dry. This technique, too, may have come from native suggestions.[32] The colony of Virginia became dependent on good-quality tobacco in order to ensure that it received supplies from the English motherland; at this point, all tobacco had to be shipped to England. The planters in Virginia had no control of the sale to other available markets. This was a hard attempt at beginning to regulate product consistency, as at this early time there were no inspection standards or quality control available between the curing and delivery stages.[33]

Connecticut Valley Tobacco

In the Connecticut River Valley, the history is different in that African-American workers began being hired for pay around the time of World War I. Slavery and Connecticut Valley tobacco are not of the same association as what was going on in Virginia.[34] The heart of cigar tobacco land has historically been the town of Windsor, Connecticut. Windsor was an English settlement, the first town settled in the state, in the year 1633. The first scouts to the land came as mediators to calm tensions between the Podunk people and the Pequot Nation, which had not only been at war with the Mohegan Nation but also claimed the Podunks' land as their own. The settlers, who hailed from Plymouth, Massachusetts, saw an opportunity to establish a trading post in exchange for the mediation.[35]

North of Hartford, Connecticut, and south of Springfield, Massachusetts, Windsor is on the Connecticut River with the Farmington River flowing through its territory. For the settlers, this meant access to trade routes and economic staying power, making the region a modern hub of development. The trade routes helped promote the trade of tobacco that was to come.

Just seven years after its first settlers, in 1640, Windsor's colonists began to grow tobacco for both personal use and for profit. The Windsor family, which has been continuously farming since William Thrall came to Connecticut in 1640, likely began the practice.[36] Sailors and traders came to Windsor as well, bringing with them a Cuban variety of tobacco seeds using the well-placed transportation routes along the northeast corridor. The Connecticut colonists felt this variety of tobacco produced milder, more fragrant leaves than the *Nicotiana rustica* grown by the Native Americans living in the area. They eventually grew a variety called shoestring, so named because it produced narrow, coarse leaves. Shoestring was not only grown in the Connecticut River Valley but in tobacco-producing counties in Pennsylvania as well.[37]

As mentioned previously, the colonial period was not a simple time in New England, especially in regards to the laws and sentiments surrounding tobacco. Tobacco legislation at this time illustrates that colonists enlisted legal measures to regulate use, if they could not entirely prevent it. In 1640, the same year that the first tobacco was being raised in Windsor, protective legislation forbade Connecticut citizens to consume any tobacco grown in other colonies.

> *It is Ordered, that what prson or prsons within this jurisdiction shall after September, 1641, drinke any other Tobacco but such as is or shalbe planted*

CONNECTICUT VALLEY TOBACCO

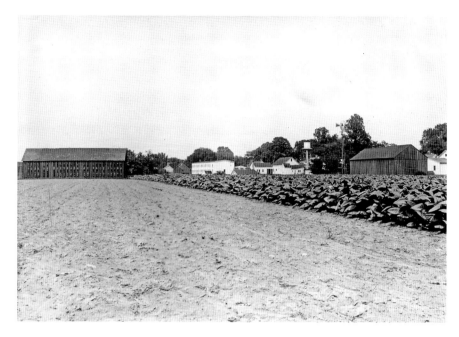

A field of Broadleaf at Shepard's Farm in South Windsor, Connecticut, in 1933.

within their libertyes shall forfeit for every pound so spent Fiue shillings, except thay haue license fro the Courte.[38]

The 1640 order is unclear whether the regulation was to stop economic competition from Virginia by pushing Connecticut residents to plant their own as a measure to promote production for profit within Connecticut, or if it was to put negative pressure on the people who chose to "drinke," meaning use, tobacco altogether by protecting them against the ills of tobacco use in general. Regardless of the unclear reasoning behind the ban of tobacco from outside of Connecticut, just a few years later, on January 28, 1646, the general court passed a regulation regarding "the order concerneing paying 5s a pownd for taking tobacco not growing within this jurisdiction, is repealed."[39] The bottom line is that what the repeal meant at the time is speculative. Perhaps the people were doing what they were supposed to do, not using tobacco from outside of the Connecticut River Valley, too well.

One possibility was that the repeal responded to the fact that a ban on tobacco from outside of the Colony of Connecticut's territory did not stop its people from using it. Instead of a ban of tobacco imports, the general

court proposed to regulate the proper use of tobacco instead. On May 26, 1647, the court put forward the requirement that anyone, meaning men, who wanted to use tobacco had to be over the age of twenty, in good physical health, and even had to have a certificate that proved he had a good reason to take tobacco. The tobacco had to be used privately in the "fyelds or woods" or ten miles away from a public space. If offenders broke these rules, they faced a fine of sixpence.[40] These are all clearly attempts at regulating a weed that was new to the people of this time and had deleterious effects on people's health and beliefs.

As far the Connecticut laws were concerned, the dominant view of tobacco users was that they were the same type of folks who were lazy and hunted for fun instead of necessity.[41] This stigma ultimately meant little in the face of growing consumption. The people of colonial New England demanded product that sometimes could not be produced fast enough. Prior to the bans of 1640, tobacco was brought from Virginia and the West Indies, but the ban on imported tobacco may have been a way for Connecticut lawmakers to muscle in on the foundation of a new tobacco powerhouse.

Whether it was meant to end tobacco consumption or to force Connecticut planters to grow more tobacco, a 1660 declaration from the governor of the colony of Connecticut, John Winthrop the Younger, admitted that "tobacco has brought some good crops."[42] The colony of Connecticut was producing enough tobacco that when the Committee for Foreign Trade and Domestic Plantations wrote to the governor in 1680 with questions regarding what imports the Hartford area had shipped in, the governor reported, "We have no need of Virginia trade, most people planting so much tobacco as they spend."[43] This was a way of saying that the colony was doing quite well in taking care of its own tobacco needs.

At the end of the seventeeth century, Massachusetts, too, had a sizable amount of tobacco in stock. So much so, that one could imagine piles of tobacco in rooms. This imagery comes from an event rooted in significant tension in Deerfield, Massachusetts, between English settlers and the native people, who were allies of New France. In 1694, when Daniel Belden's house was attacked by members of the Mohawk Nation, his daughter Sarah escaped being taken or killed by hiding "herself among some tobacco in ye chamber and so escaped."[44] Tobacco certainly did not actually save the day by any means, but it is interesting to think that enough tobacco was in the Beldens' tobacco chamber, or barn as the case may be, that a person could hide in it to escape in the midst of a chaotic situation.

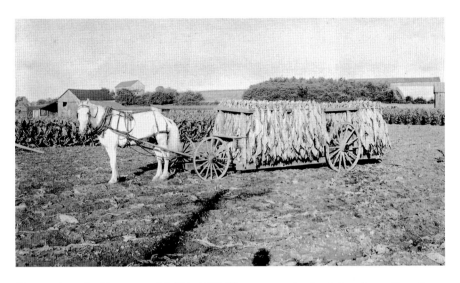

Harvest time of a Havana seed field in 1925. The carts used to haul the tobacco from the field to the sheds are called riggings.

In the eighteenth century, it is clear that there was global use of tobacco, it was internationally traded and people held conflicting opinions about it. In 1704, the Connecticut River Valley was exporting tobacco from Wethersfield, which was a trade hub about forty miles up the Connecticut River from the coast, to the West Indies.[45, 46] Tobacco was written into legal records as well as personal records. Captain Ebenezer Grant, a Windsor man who was apparently fastidious in his accounting, documented the expansion of commercial trade between southern New England and the West Indies in the 1740s.[47] There was not only an expansion, but also a hefty sales tax, as only a businessman would note. On an order of 459 pounds of tobacco, Grant had to pay a duty of 100p, a hefty fee. Tobacco was certainly a lucrative product to trade. More than a decade later, Grant shipped 26,000 pounds of tobacco grown and cured and packed into shipping barrels by the Ellsworths of Windsor.[48] The trade was growing, although functioning not nearly as powerfully as the southern competition in the Virginia Colony, which benefitted from its labor force of African field slaves.[49]

While colonial era travel took quite a while by today's standards, adventure to foreign coasts was still common. In fact, tobacco history owes much of its fame to travelers. In Englishman John Cockburn's *A Journey over Land, from the Gulf of Honduras to the Great South-Sea*, the

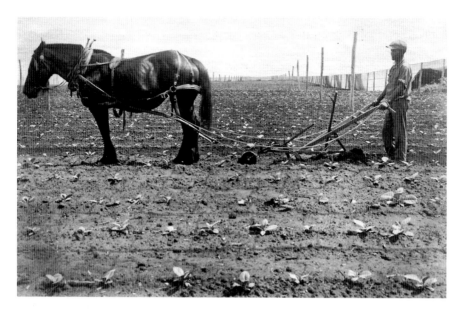

A one-horse cultivator seeder to turn up the soil underneath shade tents, 1929.

author wrote the first account in English of cigars.[50] The mariner and his comrades were offered *seegars* to smoke by friars in Costa Rica in 1731, which were described as leaves rolled up in such a way that the seegars were both the tobacco and the pipe all in one. The seegars were smoked by the native women and men. Cockburn did not seem impressed by the construction of seegars. Instead, he commented that it was unfortunate that they did not have pipes to use.[51]

Just as with the people of Costa Rica, New England tobacco was a part of the economic and social systems in the mid-seventeen hundreds across society.[52] In short, smoking tobacco was commonplace for colonial women. The women of colonial New England were said to smoke it throughout their day. They smoked a pipe in bed, while making bread and even cooking.[53]

A Connecticut woman is credited with having rolled the first cigars in 1803. However, in 1763, cigars had reputedly entered the scene in New England thanks to the exploits of the popular Revolutionary War general Israel Putnam. This may have been the introduction to the concept of smoking tobacco by rolling it into a tube shape. Putnam was a notorious figure who slayed wolves, won battles for the British and served General George Washington during the American Revolutionary War. His biographers have said that for nearly a decade, Putnam, who was

eventually made a colonel, traveled the Eastern Seaboard from Havana to Montreal as a true adventurer of the Atlantic world.[54] His larger-than-life adventures likely contributed to the myth of him bringing a donkey packed with Cuban cigars to Connecticut. Other assertions state that he took a handful of seeds in his pocket so that he could raise them back at his homestead farm in Connecticut, but this tale also has no solid documentation.

The Battle of Havana, which Putnam and his men helped British troops win, led to a great deal of plundering. They took war prizes of money and goods aboard ships, so a donkey and a multitude of cigars *could* have been part of that bounty taken from Cuba. However, the details of the said booty have been left off the official records. In fact, hardly any of Putnam's contemporaries or biographers even give mention of tobacco and certainly no mention of cigars at all. Putnam's lifetime of deeds was called heroic and his adventures romantic, which is not to say that they were not true. But perhaps this tale of how cigars were brought to the Connecticut River Valley should be taken with a grain of salt.

Still, cigars were making their way north from their origins in South and Central America one way or another. With the popular hero Putnam's name endorsing them, cigars, like tobacco agriculture itself, was expanding. By 1783, a few years after the Revolutionary War, the cultivation of tobacco expanded rapidly by sixty acres in areas of Whatley and Deerfield, Massachusetts.[55] Another round of attempted regulations only increased the tobacco trade. A year later, in New London, the general assembly passed an act to regulate how tobacco was cured and packed, but they repealed it six years later, in 1790.[56]

One has to keep a few things in mind regarding tobacco in the eighteenth century. Although it was growing in popularity, Connecticut did not grow it en masse. In fact, for some towns, prior to the eighteen hundreds, very few farmers grew tobacco. Those who did grew it in small quantities for either chewing or personal, homemade cigars.[57] Such was the case in East Windsor, where each farm would have about an acre or so more per farm. However, tobacco was a crucial income source for those who did plant it, serving as a cash crop while a family lived on the livestock and food that they grew well into the nineteenth century.

Connecticut Valley Tobacco

To explore the colonial era in the Connecticut River Valley in person, check out:

The Windsor Historical Society
Home of the "Hands-On" Strong-Howard House
96 Palisado Avenue
Windsor, CT 06095
Hours: Open Wednesday through Saturday
11:00 a.m. – 4:00 p.m.
Closed Sunday, Monday, Tuesday and major holidays
(860) 688-3813

Find out more at www.windsorhistoricalsociety.org

3

MORE GUNS, MORE TOBACCO

THE 1800s

The nineteenth century shaped the American character like no other. This was the century of Lewis, Clark and Sacagawea crossing the continent, an era of naval dominance and whaling and the war that divided this country over the right to own other people—the Civil War. It was a time of expansion of land and ideals, of industry and domineering spirits. Guns, guts and tobacco fueled the drive for western expansion. And while this period of history is characterized by very masculine pursuits, women are actually at the center of cigar production.

Chewing remained a popular way of enjoying tobacco in America through the first part of the nineteenth century in such a strong way because it was a clear way of being American, even a "prideful variant" from European methods of taking tobacco, such as snuff. Margaret Taylor, wife of the famous Mexican War general, chewed and smoked tobacco. Taylor was the daughter of a Maryland tobacco farmer and from the age of twenty-one onward lived with her husband on the American frontier for nearly forty years. During her time traveling, she may have smoked pipe with her husband. This was not unusual of the antebellum period. Some accounts say that in her later years, while she was the First Lady, she smoked a corncob pipe. At the time, that was an accusation, much like colonial-era insults, that meant she was a woman of less than high quality.[58] The Connecticut River Valley region even had a term, *fudgeon*, for chew. However, while British witnesses to the act of chewing tobacco loathed it, the American partakers reveled in their

rumination with pride.[59] Enjoying tobacco in any way they pleased was a show of Yankee uniqueness.

The concept of rolled tubes of tobacco for smoking is a South American practice that traveled via the sailors of the Atlantic. However, the birth of the modern cigar industry did indeed begin in the Connecticut River Valley. By now we know that the European colonists learned about tobacco from the native people of North America, who took tobacco in pipes. And we know that smoking leaves rolled up into a cigar was supposedly brought to New England from the Caribbean by General Israel Putnam about 1763. If true, it was because he thought that Cuban cigars were a better method of smoking *and* better tasting than northeastern tobacco.

Another story about the introduction of cigars to New England centers around a woman by the name of Sally Prout of East Windsor in 1801. Prout was a farmer's wife during the era of Napoleonic Wars and Yankee tin peddlers. There was a shortage of tin in America due to the high taxes on British exports. The lack of tin made making exporting chewing tobacco challenging. Legend has it that the clever Prout "invented" rolling tobacco lengthwise and sealing it with a damped outer leaf to circumvent the need for tin in tobacco boxes. If the Sally Prout of local legend was real, she was likely a businesswoman in a modern sense. Records show that a woman named Sally Prout was born in the area, but based on her baptism records, she would have been between the ages of ten to thirteen at the time she would have been married and began making cigars.[60] That Sally Prout is unlikely. The other option is that she was the wife of a tobacco worker from Virginia who was brought to South Windsor by chewing-tobacco manufacturers. Reportedly, Prout and her fellow female cigar producers produced crude "paste segars" that "were sold to storekeepers for one or two dollars per thousand," which was about a day's worth of production for her staff. The storekeepers sold them at a high markup price of one cent per cigar.[61]

Throughout the nineteenth century, cigar making *was* a family cottage industry. Women, men and even the children would be integral in producing the greatly demanded product. They would pack the tobacco for shipment out of seaports.[62] After 1810, a man named Horace Filley set up a manufacturing business of the twist-end cigar in close proximity to the business that Prout had established. The manufacturing location was likely attached to the Filley family farm.[63] By 1846, Filley also had a home in Bloomfield, where a tobacco warehouse allowed him to expand his expanded farm. Filley went on to be a tobacco dealer in the city of Hartford. The next owner of the land continued farming tobacco, with excellent output.[64]

The demand for cigars from the Valley quickly became so great that cottage industries like Prout's and Filley's became obsolete. Cigars needed to be produced in warehouse-sized production plants to be able to give the buyers Short-Sixes, twisted Supers and the Long Nines.[65] Aside from the businesses that Prout and her East Windsor contemporaries may have started, the first true cigar factory was built in 1810 in Suffield, Connecticut. The company was formed and opened in Suffield in 1810 by Simon Viets. As part of his plan, Viets utilized the international popularity of Cuban, or Spanish-style, cigars and hired a man from Cuba to teach his workers how to roll cigars.

The workers, who rolled hundreds of cigars each day, were local women. The cigars the women made day in and day out were sent not only around the nation but across the Atlantic as well. Good-quality cigars were bartered by Yankee peddlers, poor-quality cigars were shipped to the West Indies for slaves to smoke and average cigars would be given to the usual crowds at taverns for free by the owners as thanks to their regular patrons.[66] The quality of the cigars improved overall with the factories like those in Suffield and Southwick and the many others that sprang up rapidly throughout the Valley.

One such successful cigar factory, still standing today, is the C.J. Gillett Cigar Factory and Warehouse. The factory was originally situated at Gillett's Corner in Southwick, Massachusetts, where the extended Gillett family farmed for much of the eighteen hundreds. Charles J. Gillett grew up in the small town of Southwick, where he and his father raised their crop of tobacco at what is now the corner of Vining Hill Road and College Highway.[67] While Gillett began life as a farmer, at the young age of twenty-four, he listed his occupation as cigar manufacturer.[68] In 1872, he constructed a factory and warehouse where he could make cigars using his own tobacco. The structure featured many southerly and easterly-facing windows to provide light for the primarily female workers from the local area, rolling the tobacco leaves into cigars. Cigars made there were once sold throughout the United States under several brand names, including "Eastern Train," "Old Iron King," "Queen Ann," "Sporting Friends" and "Gillett's Standard Cigars."[69]

In the nineteenth century, cigar factories popped up across the eastern United States. The popularity of cigars fueled not only the building of new factories but also new advancements in how cigars were shipped and even in the tobacco plants themselves. Residents built one of many warehouses in Windsor in 1824, this one five miles north on the Connecticut River, to handle tobacco export and quality control. That area is still called Warehouse

Point today.[70] The following year, Connecticut River Valley tobacco began to be raised on a serious commercial scale, and in only a few years it rose to local and national prominence.

The geography of the Connecticut River Valley is a chief component in why tobacco and many other crops grow so well compared to the rest of New England. In the mid-nineteenth century, Edward Hitchcock of Amherst College discovered that the Connecticut River Valley is the remnants of the

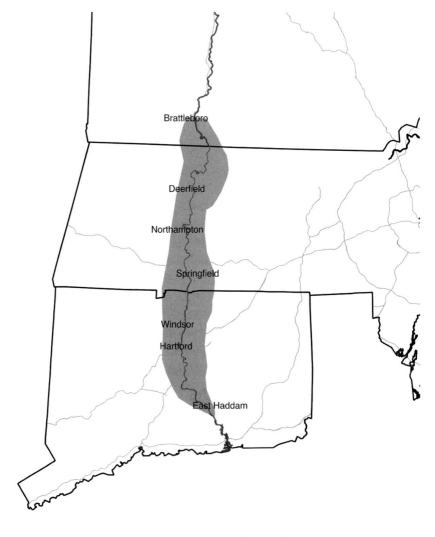

The region of tobacco cultivation in the Connecticut River Valley in the eighteen hundreds. *Map by Connor Brooks.*

ancient glacial lake, now called Lake Hitchcock after its discoverer, which covered this area roughly fifteen thousand years ago and lasted about three thousand years. This lake became a valley as the natural shifting of earth continued to mold the region. The lake stretched from upper Vermont to the Rocky-Hill area of Connecticut. The Connecticut River Valley region in which tobacco is grown runs from roughly Brattleboro, Vermont, to East Haddam, Connecticut. Tobacco was grown in these far northern and southern tips of the Valley from the 1860s to 1900 at the latest, during and after the Civil War.

Around 1830, farmers who wanted to ensure that cigar leaf buyers would purchase their crop fine-tuned the special Valley tobacco—Broadleaf. For decades, tobacco farmers have crossbred varieties of Cuban seeds and *Nicotiana rustica* to make a plant that was as hardy at the native tobacco but as large and delicious as the far southern varieties. Broadleaf tobacco emerged from the process of "sweating" tobacco to enhance curing. The origin of this technique may well have been accidental. During a shipment from Warehouse Point to Germany, the long, hot trip in the ship's cargo heated the tobacco, naturally enhancing the chemical process of curing. The leaves that the Germans took out of the bundles were dark and seemingly of high quality. From that point onward, tobacco farmers recreated the process in sweating rooms attached to curing sheds.[71]

Over the next few years, tobacco farmers continued to utilize specialized techniques to pull desired results from the leaf. Cross-pollination and other plant hybridization were not the only ways to create money-fetching tobacco. At the time, dark-leafed tobacco was all the rage, and with so much money at stake, farmers wanted to give buyers what they wanted. In order to keep up with demand, farmers sprinkled gypsum powder on the plant as it was growing to thicken the leaves. The thicker leaves would remain darker than the thin leaves when cured. Farmers also manipulated the way leaves darkened by opening the curing barns, called sheds, at night and keeping them closed during the day.[72]

Cigars have three parts: the *filler*, which can be leaves tightly rolled together, or mixed ground tobacco and other plants, the *binder*, which roughly holds the filler in, and then the *wrapper*, which is the part of the cigar that is on the outside. The wrapper is meant to be beautiful and appealing since it is what the smoker judges before smoking. The wrapper has a higher value than any other part of a cigar. This means that the leaves have to be as close to perfection as possible. Sorting tobacco by grades began sometime around the 1840s. There was only a need for two grades—filler and wrapper. The

demand for high-quality leaves and the reality that not all leaves were the same helped lead to another new concept—buyer visits to farms. Tobacco manufacturers sent buyers out to compare and select what the manufacturers would buy.[73] Older varieties of broad-leafed tobacco could be used for filler, binder or wrapper, but with a high-quality plant developed particularly for cigar wrappers, it was more likely that the farms of the Connecticut River Valley would stand out as a center of tobacco production. Those profiting from crops grown between 1830 and 1880 used their wealth for western land speculation and to help finance commercial ventures, including the Hartford insurance business.[74]

Farther north in the Valley, planters in Massachusetts towns like Hatfield and Hadley jumped into selling their tobacco directly to cigar manufacturers instead of relying on cottage-industry cigar production. They grew more tobacco than more typical crops of that region like broomcorn and onions. In that same year, B.P. Barer started to cultivate seeds that were brought up from Maryland. This variety had wider leaves than shoestring tobacco, making it a staple in the Valley harvests. This leaf eventually was crossbred into Broadleaf tobacco.[75] Tobacco was more lucrative than food crops for a few years because foodstuffs were now being shipped from farmers in the West to the East.[76] The entire Connecticut River Valley yielded about one and a half million pounds of tobacco leaf in 1849.

However, the true heart of the Connecticut River Valley remained Windsor, not simply because it is where tobacco first began being cultivated by colonists for profit, but because of its rich soil. There is the old joke that New England's number one crop is rocks, hence the famous stone walls that wrap its landscape. Due to the seasonal shifts of the former Lake Hitchcock, the soil in the Connecticut River Valley is a lush, sandy loam and generally has fewer rocks than other parts of New England. This soil type is normally made up of sand with varying amounts of silt and clay, which allows for good drainage and air circulation around the roots of the plants. Tobacco thrives in sandy loam. In Windsor, there is an average of thirty-three inches of this topsoil.

Even with a soil pedigree of that quality, the repeated farming of the Valley began to take a toll on the earth. By the 1850s, large farms suffered from manure and fertilizer shortage. During this time, commercial fertilizer came into use. Fraudulent salespeople begin selling fake fertilizer, which lead to brief plant suffering. In an active response to the faux fertilizer that began to make its way around the Valley, agro-scientists started to work toward new standards in soil nutrients, the results of which lead to new frontiers in tobacco production by the end of the century.

In addition to fertilizer maximizing the soil, techniques in curing and sweating tobacco were developed by farmers desirous of making the most of their cash crop. Harvesting the plants began with chopping them at the base, then spearing the entire thick stalk onto a lath, which is like a rough yardstick. The tobacco laths were then hung in shacks or sheds to cure. Sweating the tobacco during or after the curing involved heating the tobacco to change the consistency and enhance the flavor. This type of focus on cigar tobacco perfection became more commonplace between 1849 through the end of the Civil War.[77]

By 1860, there were many cigar manufacturing hubs that reveled in the production coming from the Valley, out of Pennsylvania and up from Cuba. Included in the top ten cigar manufacturing regions were Hartford County in Connecticut and Hampden County in Massachusetts. These places were not the top production centers, however. Philadelphia ranked at number one and New Orleans at number ten.[78] The cigar trade that emerged from the Connecticut Valley had been surpassed by others who could produce enough materials and workers. In 1863, the fame of quality Connecticut tobacco was raved about in newspapers as far as New Orleans, one of the manufacturing hubs where Connecticut tobacco was shipped.

During the Civil War, the Connecticut River Valley saw the production and price value of Connecticut Broadleaf expand exponentially—yielding up to ten million pounds per year.[79] The reason for the sudden increase lay with the demand for tobacco by soldiers, but the temporary national disruption of southern tobacco trade out of Virginia did not hurt.

In search of profit, the North shipped tobacco to both sides, as they did with guns and other ammunition. The war ended in 1865, with the North as the victor over oppression and secession. The Civil War served as the biggest boom for Connecticut Valley tobacco behind the era of the Yankee peddlers.[80] In the vacuum that the Virginia trade left, the Connecticut River Valley producers picked up the slack in growing tobacco for pipe, chew and cigars, which were shipped to men on both sides. The forty million pounds produced in the Connecticut River Valley during the four years of war represented the steepest rate of increase that the region would ever see.[81]

After the Civil War, it is unclear as to why Victorian sensibilities developed about women smoking tobacco. While it had been quite normal for women during the colonial and antebellum eras to partake in the leaf, society considered women smoking to be unseemly from Reconstruction onward. "In Victorian America…women did not smoke and respectable men did not smoke in their presence because spheres occupied by men and women

had diverged, at least in the middle and upper-middle classes."[82] This was a gradual change, however. In the 1870s, during a height of railroad travel, a woodcut drawing was made depicting a well-dressed woman smoking with the caption, "A lady on the C.H. & D.R.R determines to enjoy her rights—she takes her place in a smoking car beside her husband, and joins him in puffing a Havana cigar."[83]

The tobacco-growing game changed once again with the success of the Havana leaf seed. In the 1870s, the U.S. Department of Agriculture gave out samples of the Havana tobacco seeds to promote economic profit in the United States. The plant was suitable for even the poorest of soils. It was good for not only wrappers but filler as well. While it yielded less than the Connecticut variety and did not consistently produce the highest-quality wrapper leaves, its growing popularity meant that all four of the tobacco-producing New England states grew Havana.[84] In 1875, the tobacco industry was so strong that buyers would roam all the region's farms and make generous offers to the growers.[85]

Meanwhile, as the Connecticut River Valley product diversified, so did the tobacco growers. The region saw a massive influx of Polish and other Eastern European immigrants.[86] They came with hopes of carving out a life for themselves in places like Hadley, Massachusetts, or New Britain, Connecticut. In Hadley, where tobacco had been planted for personal use on most farms since the beginning of the nineteenth century, there was a jump in Polish tobacco growers and production from the 1860s onward. There was a corresponding increase in production; in the Hadley area, tobacco production went from from 138,046 pounds in 1850 to 7,289,275 pounds two decades later.[87] Connecticut (Windsor being the epicenter of tobacco cultivation in New England) had a stunning 472,000 pounds of Broadleaf tobacco being grown by the 1840s, and Massachusetts offered roughly 65,000 pounds each season. These numbers predictably continued to grow, as Connecticut and Massachusetts boasted the richest soils along the Connecticut River. The incredible jump in growth of the tobacco industry is more surprising in Vermont and New Hampshire. The state of New Hampshire produced a meager 50 pounds in the 1850s and within twenty years was pushing out 155,334 pounds. Even more impressive was the leap from no noted tobacco production from Vermont per the 1850 census to 72,671 pounds by 1870.[88] This upswing in farming production within spans of twenty to thirty years paints a clear picture of the demand for cigar-quality tobacco. The most staggering number here is 15,870,399—the total number of pounds that New England produced between 1840 and 1870.

Those numbers may even be low estimates according to some researchers.[89] That is an incredible feat, considering the demand for tobacco surrounding the Civil War and despite the rudimentary tools being used.

The Sumatran leaf challenged the Havana leaf tobacco after the Civil War.[90] Growers in the northern Connecticut River Valley had put a lot of effort into perfecting Havana tobacco, so when the popular cigar style shifted once again, the tobacco planters suffered. In 1870, Hadley was overproducing the tobacco that was going out of popularity, which sent production into a sort of depression for the next twenty years.[91]

Sumatran tobacco was first imported in 1885 for use as filler tobacco, then rapidly accepted as wrapper in 1886, to much uproar from Connecticut Valley tobacco growers.[92] Farmers demanded tariffs and other protective action against this foreign leaf taking away their profits. They banded together to push Congress for a tariff to protect their livelihoods, and by 1894 duties were placed on Sumatran imports. This once again turned the market in growers' favor.[93] Outside of the Valley, all around the nation, the Sumatran cigar leaves were causing a stir. Corporations blamed the leaf

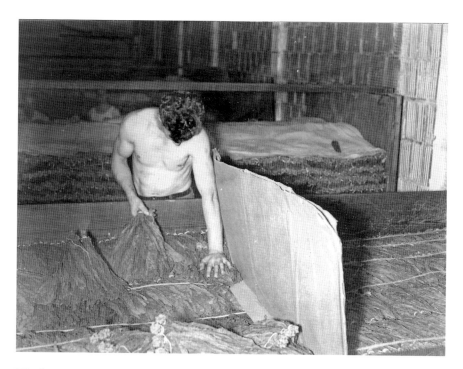

Warehouse operations involve sorting tobacco, packing it and checking to see how the tobacco is aging. Checking it for shipment in November 1937.

for falling sales, which was also due to a general economic depression, not just competition. They launched negative propaganda about cigarettes, with accusations that cigarettes were laced with drugs and poisons.[94]

The entrance of new tobacco followed by a period of shifting preference was all part of the natural shift in markets, tastes and fashions of the times, as reflected in cigar tobacco. It is the same today—farmers must and do react to what the market needs. However, the fact that the tobacco growers worked together to demand protection from the government is significant. It ushered in a new time of politics in the tobacco industry and foreign relations.

To explore the cigar factory age in the Connecticut River Valley in person, check out:

The Southwick History Museum
Home of the C.J. Gillete Cigar Factory
86-88 College Highway
Southwick, MA 01077
Hours: The C.J. Gillett Cigar Factory is open on the second and fourth Sundays of each month from June through October. It is also open by appointment and for special events.

Find out more at www.southwickhistoricalsociety.org

4
THE PEAK YEARS
1880s–1930s

Throughout the 1880s and 1890s, world trade competition pushed the cigar tobacco market and necessitated improvement to the soil and plants in the Connecticut River Valley. At the turn of the twentieth century, three primary factors affected the tobacco industry: sheds, the development of the famous Shade tobacco and the labor force.

Tobacco loves to be grown in hot, humid weather and it loves to be cured in toasty sheds. The weather of the Valley was instrumental in the short, but productive, growing season of New England. The heat and humidity of the Valley could even be described as hotter and more humid than other regions because of the two rivers flowing in the same geographical space. Growers built tobacco sheds throughout the region of the Connecticut River Valley in greater and greater quantities. Men would even travel in teams across the countryside to build sheds with raw timber, simple tools and teams of mules to haul the frames of the great behemoths into place. The roving shed builders would be housed at inns while they built curing houses. The sheds, still found across the landscape today, are easy to spot once you get an eye for them. They tend to be long with vertical slats down their entire length. They will not feature windows and they will always have the telltale hardware of long hooks to hold the slats in place.[95] The slats open and close for manipulating the curing process or protecting the valuable leaves from a storm at a moment's notice.

Fertilizer was also big business. Even into the twentieth century, traveling salesmen were still peddling fertilizer. Buyers had to be wary of traveling

salespeople, who often tried to sell low-quality sawdust and the wrong kinds of manure because there were no standards or regulations in place to protect the farmers who desperately needed to improve their soil. The soil, while naturally rich, had been continuously farmed for hundreds of years.

One fertilizer company, consisting of growers who raised their own tobacco, knew what it was like to need genuine fertilizer. The company, Olds and Whipple, vied for business and crafted their own specialized tobacco fertilizer in order to keep farmers in supply with a quality project. The Hartford-based company would greatly emphasize that they used science to make a "complete tobacco fertilizer." The company enjoyed booming success in the 1910s because of their promotional slogan that declared that while farmers could not control the weather, they could still control the fertilizer that they utilized.[96]

In reaction to the traveling fertilizer frauds, farmers held a meeting in Windsor's town hall to discuss how to control and organize the fertilizer dilemma. The 1891 meeting included big names in turn-of-the-century tobacco farming: Ellsworth, Brown, Thrall and Dubon, plus Dr. Jenkins of the Connecticut Agricultural Experiment Station of New Haven. They directed the Connecticut Tobacco Experiment Company to conduct fertilizer experiments. This was one of the steps in scoping out the region for a scientific experiment station, which would go into place two decades later. The next step followed in 1898, when the Department of Soils of the U.S. Department of Agriculture suggested that all the soil of the Valley be tested for a soil makeup map. At the end of the century, the Department of Agriculture reported that the Farmington River region, which abuts and overlaps the Connecticut River Valley, actually has three soil types that tobacco thrives in. At the time of the report, 1899, the government report called the tobacco industry the most important aspect of the region.

At the cusp of the twentieth century, tobacco growers in Florida and Georgia were experimenting with new techniques in raising tobacco at the request of the Department of Agriculture to challenge the threat of Sumatran tobacco to profits of American cigar tobacco growers. This fine-grained leaf imported from Sumatra began to replace the wrapper from the Valley. The production of tobacco was once again revving up in the Valley after a significant slump in demand since the 1880s, and government officials and growers were working to make sure that Sumatran tobacco did not muscle its way into the wrapper market for good. The soil in Florida was reported to be most similar to that of Sumatra, so the focus was on raising tobacco there to find out what a key component of comparable tobacco was.

Connecticut Tobacco Experiment Company stock certificate issued to H.H. Ellsworth in 1892. They experimented with crossing Broadleaf, Havana and Sumatran-grown varieties.

Experiments were not terribly remarkable until it was noticed that varieties of tobacco grown under artificial shade, such as the shade of palm trees or that of slants meant to block the sun, but still exposed to heat and humidity, grew fine leaves clear of blemish or thick veins.[97]

The shade experiments to recreate a product similar in texture to Sumatran tobacco could have been further explored in Florida. However, the Department of Agriculture was partial to the state of Connecticut, especially after the soil testing done in 1898.[98] The grant to try to grow "shade" was carried out by Dr. Marcus Floyd on River Street in the Poquonock area of Windsor. The 1900 trials in shade growth techniques involved seeds from Florida-grown Sumatran plants and Havana seeds.[99] The "shade" used in the Connecticut Experiments was a cotton material already in use for another purpose—cheesecloth.

The first shade tent was put up on River Street in Windsor in 1900. The cloth cut sunlight and raised humidity under the tent to increase the heat of the natural New England summer weather by mimicking the tropical weather of Sumatra and South America, respectively. The cloth was sewn on industrial looms that reached lengths of thirty-three feet. To this day, one of the slang words in tobacco vernacular is a *bent*, meaning the distance of thirty-three feet between any two poles. The 1900 experiment made use of

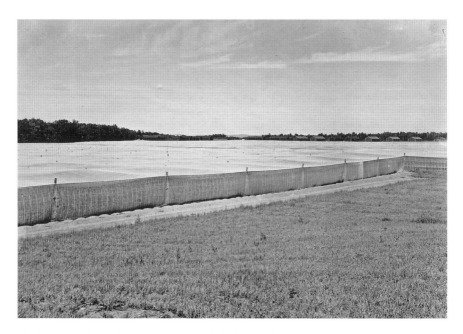

Shade tents as far as the eye can see—straight into the horizon at Hartman Tobacco Company in Bloomfield, Connecticut, in 1937.

a tent crafted of thick poles, over which the cheesecloth was placed with wire. With that shade tent and a hybrid plant of Sumatran, Cuban and Connecticut Broadleaf, the agro-scientists not only matched Sumatran leaf, they started a whole new tobacco species unlike any other used in cigar production.

The term "bent" is not only used to describe size in a Connecticut Shade tobacco field. The term finds a second meaning within the tobacco sheds as well. Tobacco sheds are tall, and deep as well, three bents wide to be precise. The bent size inside of a shed is about fifteen feet deep. Each shed normally has three bents' worth of space so that tobacco can be hung on either side of a shed, from the peak down to the lowest level and allow for work space in the middle of a shed. The bent also indicates how much tobacco a shed can hold.

Thus, in 1901, Connecticut Shade tobacco was born. It has a worldwide reputation, but that does not mean that the leaf did not have a rough start in the playing field. While growers, buyers and dealers all turned their eyes toward the shiny new possibility of the domestic Shade tobacco, it did not fare well in the 1902 growing season or the 1903 season. Early experiments played with the color of the leaves, as well as the elasticity and body that the leaf held while it was fresh and after it had been cured.

The workers for the International Tobacco Culture Corporation in 1902. These workers were likely a mix of locals and immigrants.

Even if the leaf needed tweaking by crossbreeding to enhance certain traits, it was established to be a variety worth keeping. It was noted in 1901 that just one and a quarter pounds of a Sumatran variety grown under a tent, which was how Shade was first described, could wrap about one thousand cigars.[100]

Connecticut Shade tobacco was actually not grown very much in nearly the first decade of its existence; experiments continued with the avid supporters of the plant. Much cross-hybridization was done until a variety called the "Hazelwood Cuban" was found to be a successful crop.[101] The perfect leaf for premium cigars would be over a foot long, golden tan in color, with fine, nearly unnoticeable veins. This soft leaf would feel like fine velvet even after weeks of curing.[102]

In 1907, the Department of Agriculture, now clearly involved with the tobacco industry, hired tobacco grower John B. Stewart of Connecticut to study the new Shade crop's production quantities and monetary value. The grower reported how many pounds he grew on three acres, what it cost to grow that acreage, what the tobacco weighed after curing (in which tobacco loses roughly 80 percent of its water weight) and what the total profits for the grower and buyer ended up being. To simplify this lengthy report process,

The Valley Laboratory in Windsor was established by the board of control in 1921 to investigate cigar wrapper tobacco production and disease control.

Stewart spent roughly $713.00 per acre. In return, he pocketed about $1,143.00. It is said that from that clear report onward, Shade tobacco meant profit. It was a successful plant that would continue to be grown in the Valley.[103]

It took farmers and scientists with brains and innovation to push tobacco in new ways. In 1911, O.J. Thrall of the long-rooted Thrall

family in Windsor helped to establish the Shade tobacco industry firmly. Throughout the early nineteen hundreds, descendants of the Thrall line contributed to tobacco inventions such as a mechanical sewing machine and special fermenting warehouses.[104] The Connecticut Agricultural Experimental Station led the way in scientific development needed for the success of healthy, disease-free tobacco. Established in 1921, the tobacco substation was built as a branch of the New Haven Experimental Station. The stations, run by the state government, employ agro-scientists to help people will soil and plant pathology.

Shade tobacco was first considered to be good enough for the filler, binder or wrapper on a cigar. But the quality of the thin, light leaves quickly made it worth being marketed as a wrapper leaf exclusively. Shade tobacco took the place of *sungrown*, the common term for the shorter Broadleaf and Havana plants, in the wrapper market.[105]

Growers soon realized Shade tobacco was different and had to be treated as such. This is still true today. First of all, the plant is about ten feet tall. The shade tents are nine feet tall, and each season the tobacco pokes through the top of the cloth netting. Secondly, the leaves were, and still are, picked as

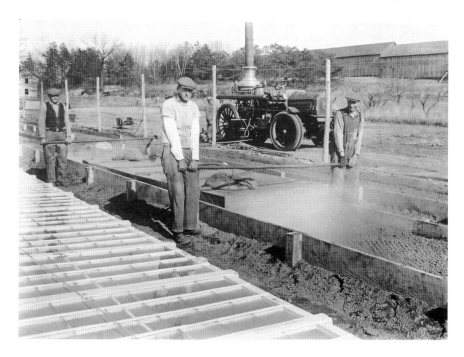

Tobacco seeds are so small that they need to be started in a contained space safe from cold and frosts. Huntington's farm in April 1933.

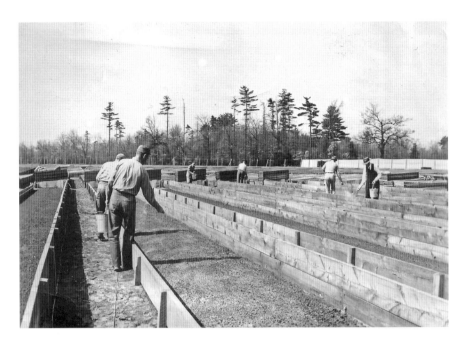

After the soil was sterilized with steam, seeds were sown in April. The seeds were mixed with humus and plaster at Imperial Agricultural Corporation, 1950.

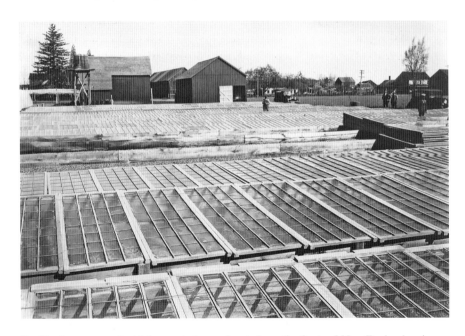

Seed beds are covered with large window sashes to keep the frosts of New England springs from harming the crop. A.A. Clark's farm, 1928.

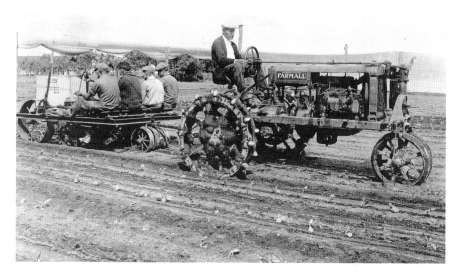

A two-row EZ Way tobacco setter with four men behind a Farmall tractor in 1930.

they became ready from the bottom up. The smallest leaves near the base of the Shade tobacco were snapped off and discarded. That process is called suckering. As the Shade grows, the lowest leaves are gently popped off of the main stalk a few at a time. In the 1910s, this task was usually performed by a child laborer, scooting down the rows on his butt. In fact, the use of young boys to sucker and harvest leaf was considered a necessity, as they had an easier time getting around beneath the plants.[106] This repetitive process had to be performed over and over. The leaves were handled like money— they were placed in wide, shallow baskets, hauled via wagon to a shed, then carefully sewn by hand with string onto laths by women. Since the earliest tobacco cultivation, the labor has been divided by the sexes. Even today, this is often true, but not at such an extreme gender divide.

The children who worked tobacco were often the family or neighbors of a grower. The immediate need for youths quickly became great. Cigar manufacturers who both farmed and made their own cigars increasingly relied on child labor for harvesting.[107] More production called for a system in which immigrant children were brought out from the cities of Hartford and Springfield to do day labor.[108] In the 1910s, the children cost little to pay and transport between farms and their home cities. Teenage girls were hauled from New York City, but they proved to be a bunch of wild lasses who ruffled the feathers of Hartford locals. The reputation they earned as troublemakers ensured that the "experiment" only occurred once.[109]

Name *John Williams*		No. *58*
Residence *Tariffville, Conn*	Voter *No*	
Nationality *Lithuanian* Age *41*	Citizen *No*	
Started Our Employ *April 1917*	Class of Work *Farm Laborer*	
Male ✓ Female	Married ✓ Single	
Last Previous Employer *Cullman Bros* Occupation *Farm*		
Plantation **SIMSBURY FARM**		

Tobacco farm workers were documented on cards like these from the 1910s to the 1940s. This card identifies a Lithuanian man working for Cullman Brothers in 1917.

The Connecticut Leaf Tobacco Association reached out to the National Urban League in 1915 to find reliable workers. The organization leaders saw and created an opportunity for young black men pursuing college educations to work in order to earn funds for continued schooling. The president of Morehouse was aware that African Americans were leaving the South for the refuges of the North, and so he worked with the students, the Urban League and tobacco growers to gradually build a program of sending students to pick tobacco for the summer, with the hopes that the young men who would earn an education at the university would stay and aid their communities after graduation.[110] This program was successful and carried on in the decades to follow.

Child laborers continued to be a safer bet for the growers who hired them. But the children were not always safe; they were used through the early 1940s, but the Connecticut Department of Labor found awful living conditions in farm camps. Plus, neither parents nor the children knew what type of adults they would be working with. Incidents in the 1930s led to efforts in improving conditions, rights and pay of the child laborers. A chief concern was the way in which children were brought between farms and home by farm drivers. The open trucks were less than safe, so parents and labor rights activists focused their energy on inducing farmers to provide safe transportation.[111]

Enter the expanding labor force. The intense stoop labor needed for the now rapidly increased acres of Shade, Broadleaf and Havana tobacco required a surge of workers that the residents of the Connecticut River Valley

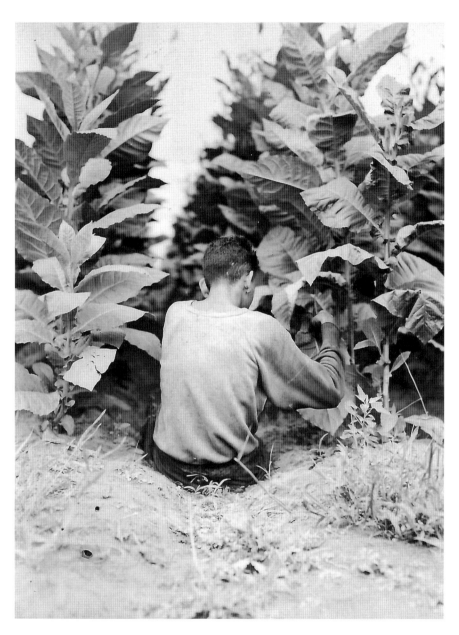

A youth suckering plants at R. Clark's farm in 1939.

had never seen before. Outside of the Valley, New York City had a serious cigar making industry. In 1900, the Federal Industrial Commission did a study of the ethnicities of the cigar industry workers. It was estimated that

33 percent were German, 30 percent Bohemian, 20 percent Russian Jewish and 17 percent all other. It was noted that almost no native-born American men or women were employed in the cigar industry.[112] Immigrants, with each new wave over the centuries, were and will continue to be the dominant workforce for jobs seen as undesirable by native-born peoples.

Cigar makers in all of the manufacturing hubs across the nation tended to be union men, and women, to a lesser degree. Cigar making involved mastering a skill through hands-on practice. In the early nineteen hundreds, small shops or larger manufacturers were options that makers could choose from, such as F.D Graves, which was a large manufacturer in Connecticut. Larger shops meant workers could focus on specific tasks, but a draw of small shops was a more social atmosphere. A well-skilled cigar roller could pick which type of shop he went to.[113] Proof of this is in the story of one of the few remaining cigar making companies in New England. The founder saw such a good cigar maker, he built his own company and paid his rollers a wage worthy of their craftsmanship.

> *Frederick D. Grave came from Osnabruck, Kingdom of Hanover, Germany in 1861 sailing on the three masted vessel "Augusta". That was in the early days of the Civil War. He went to Ohio and then New York, learning the cigar trade. In 1873, Frederick came to New Haven, Connecticut to work for the Osterweis Cigar Factory. In 1884, with less than a dozen workmen, he began making only high grade cigars adopting The Judges Cave as his trademark. In 1901, he built one of the most substantial, modern and up-to-date cigar factories in the country, where the company still is today. In 1905, there were one hundred and fifty first class cigar makers with an average wage of eighteen to twenty dollars per week working in the F.D. Grave Factory. F.D. Grave did not consider their wages to be too high, for having been a practical tradesman himself, he well knew the long time and endurance it required to become a perfectly skilled manipulator of tobacco into a first class cigar.*[114]

Unions in cigar shops achieved something special. Male and female cigar makers worked together and won rights together. This achievement, while not necessarily found in the Connecticut River Valley cigar manufacturers, needs to be explained. Women were able to socialize in a productive setting, with a degree of independence from men, which allowed for development of individualism and self-worth outside of confined home settings.[115] During World War I, male union members and

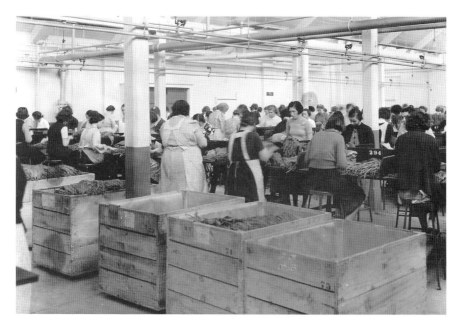

A Shade tobacco warehouse's sorting room in December 1937. Sorting was and is done by grades of quality.

nonunion female cigar makers worked together to demand and win wage increases and myriad other demands.[116]

In the tobacco fields of the Valley, not only have new immigrants been a constant character in cigar tobacco history, but American migrants as well. In 1916, two hundred southern African-American men and women stepped off of buses at Union Station in Hartford, Connecticut, and shocked the white locals. The arrival of the workers caused such a stir to Hartford that a news reporter was sent down to witness their arrival. The large group, people from Florida and Georgia, was stared at as they debarked at the station, and notes were made by the white locals on their speech and behavior. The southern African Americans evaluated them in turn. They each came for work at the American Sumatra Tobacco Company in Southwick, Massachusetts.[117] This bus of migrant workers was the beginning of a tradition of black and white migrant workers who would come up from the South to work tobacco and other crops.

During this time, African Americans were side by side with white New Englanders. The prewar era that demanded the influx of southern workers created a work environment that, while in no means a perfect utopia, was a chance for both cultures to meet in the middle over common work.

Connecticut Valley Tobacco

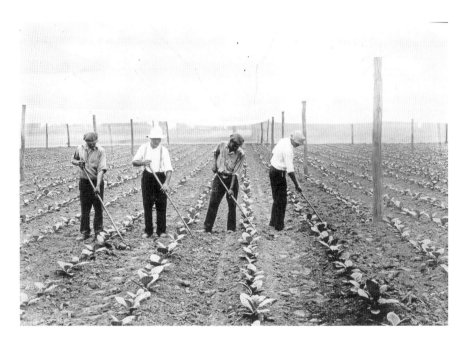

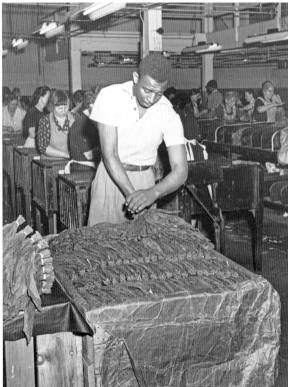

Above: Men hoeing the young transplanted Shade plants under tents at A.A. Clark's farm in June 1928.

Left: Another step in preparing tobacco for shipment to a cigar manufacturing company was carefully laying the hands of cigar tobacco into the bales, 1948.

Compared to the brutal lynching and one-sided laws dead-set against freedoms and rights that African Americans lived with in the South, places like Connecticut were a welcome escape.[118]

In an interview, Donald Clark, a Connecticut local whose family owned a tobacco farm, shed light into the patterns of labor that his farm utilized. Beginning in the 1930s, they hired almost entirely black adults who would travel to Connecticut each spring from South Carolina. Their family farm provided barrack buildings as housing and a cafeteria building where they would be served food. The cook each summer was usually one of the men who had skill in the kitchen. Each week, the workers' room and board was taken out of their checks.[119]

> *Probably in the 30s and 40s you had mostly black labor coming up from the southern states. Some Puerto Ricans were coming in and they were housed on the farm or they had a large camp for the farm laborers in Poquonock in the town of Windsor. From there they would be bussed to the farms every day. The workers were fed, housed, had their own chapel and other facilities. We also employed the youth. For many years, boys and girls picked and sewed and worked on the farm in the summer to harvest the crop right in Westfield. Many of the larger growers and larger companies felt that they couldn't get enough labor locally and so they brought in youths from states like Florida, Pennsylvania and West Virginia.*[120]

The shift of local Valley workers to munitions factories to aid the war effort had opened up the job opportunities in the tobacco and other crop sectors that gave rise to the migration. The North *was* better, but southern African Americans did come to realize that the local white population was not friendly to them or the idea that African Americans were coming to take jobs that locals considered theirs.[121] During the war, African-American women worked in warehouses stripping the leaves off of Broadleaf plants while men worked in the fields. The women were watched by white foremen who cheated them out of their fair wages. The women knew they were being shorted and were urged to make their own union to protect themselves by Red Cross caretaker Mary Seymour. A small union was started on the women's behalf in Hartford, but it did not succeed due to the tense pressure aimed against the African-American workers by not only local white union men but, surprisingly, local African-American church leaders.[122] The dynamics of all southern workers, mostly either male high school and college students attending prestigious black universities of Alabama and Georgia

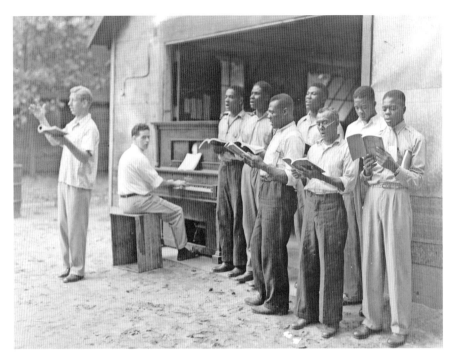

Men from the South, working to earn college tuition money, were known to sing in choirs at venues around the Hartford area, 1940s.

and teenagers and young men and women from Florida and Pennsylvania, would become more prominent in the 1940s.

Major corporations began to form around Shade tobacco. The American Sumatra Company, which was operated out of Georgia, bought a whopping six thousand acres of land in the Connecticut River Valley sometime around 1910. Other companies setting down their mark in the 1910s and 1920s include the Hartman Tobacco Company, Cullman Brothers Inc. and Consolidated Cigar. The slightly smaller companies include the likes of Otee Tobacco, Shepard & Son and L.B. Haas and Company.[123]

Everyone wanted to have a say in tobacco's multiple aspects. Co-ops came and went, such as the Connecticut Shade Tobacco Growers Association and various packing associations. These organizations all wanted a piece of the tobacco "pie." The issue with these early 1910s and 1920s associations was that they wanted to short the farmers themselves. The farmers, who invest in their own crop as risk each year, never wanted to sell the harvest for less than what they had been paid the previous year.[124] The practical problems with that were the other factors in the same era. The second issue was that the buyers

Connecticut Valley Tobacco

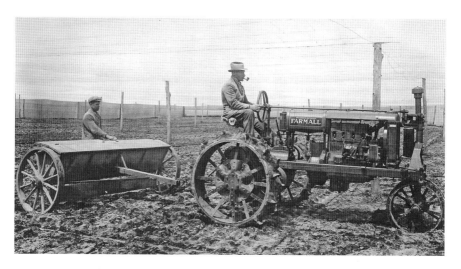

A Farmall tractor pulling a fertilizer sower in May 1929.

of tobacco were not always on the same page as tobacco packers. The packers started their own groups to protect their shipping investments, but sometimes they could not get rid of the tobacco if a buyer was not interested, which left the packing people high and dry with excess tobacco taking up space.[125] The early cooperatives were a logistical failure. In 1921, the Department of Agriculture "condemned the private contract system" that these various associations had made a mess of in favor of standardized warehouses.[126]

Tobacco production in the Connecticut River Valley reached a peak in 1921. Connecticut grew an expanse of 30,800 acres and Massachusetts grew 10,400.[127, 128] Just one year earlier, Prohibition had taken effect nationwide. While multiple factors that could not be replicated played into the size of the production that year, it should be noted that tobacco consumption overall, whether in cigars or the new kid on the block, cigarettes, seemed to be Americans' vice of choice when alcohol could not be had.

The year 1921 also saw a new experimental station opened in Windsor, Connecticut, by the federal government to help specifically with the Poquonock area. The facility's goal was to research methods adapted to each type of soil and carry out agricultural experiments in tobacco raising, such as introducing new minerals and chemicals to the growing process.[129] The science of fertilizer, which had been raved about the previous decade, was not as popular with farmers. Of course, fertilizer was bought at an increased rate in the 1920s and has always been needed, but the growers began to be more interested in minerals such as gypsum

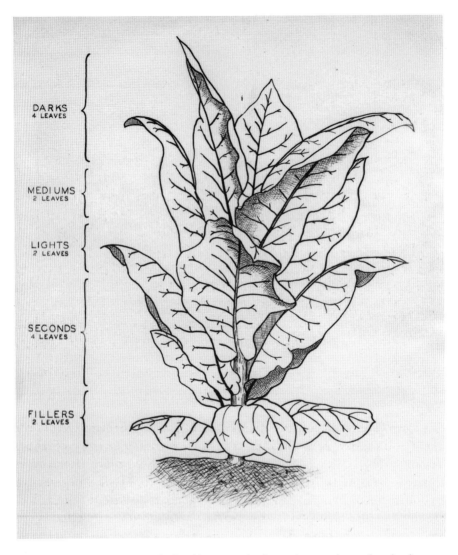

Grades of a Havana plant, as depicted by agro-scientists at the experimental station in 1938. The diagram indicates the cigar leaf color.

and calcium than organics.[130] The experimental station is still open today in Windsor—anyone can call and take samples of soil to be tested there, as it serves the entire public.

Another slump followed the 1921 production boom, although this one was not as severe as newspaper reports of the 1930s made it out to be.[131] The massive acreage grown in the early 1920s would be hard to top,

The 1927 Connecticut State Fair at Charter Oak Park in Hartford featured this exhibit of the new marvels of tobacco plants in the Valley.

but *many* factors played into the pullback in acreage. One such factor was the invention of a machine that made cigars. The price of cigars began to drop, which meant that buyers asked for more Connecticut Shade tobacco to be produced. By 1922, the machines could be operated by four women and put out four hundred cigars within one hour. This machine method allowed for each girl to push out three hundred cigars in a union eight-hour day.[132] The machines allowed for more room in manufacturers to have a say in tobacco prices. By that time, such technology began to push the small cigar shops out of business. The cigarette industry took a huge chunk from the cigar business trade. Their jump in popularity is more considerable that that of cigar production—8 billion were made in 1910, then 124 billion by 1931. Cigarettes took over the market by storm and a correspondingly large financial chunk from the cigar business.[133, 134]

Furthermore, cigars had the appeal of being hygienic. Hygiene was a fairly new craze after the turn of the century. One large advertising

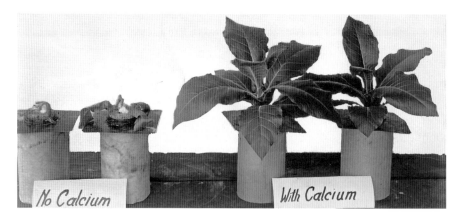

The experimental station worked with chemicals and minerals to grow successful and resilient plants.

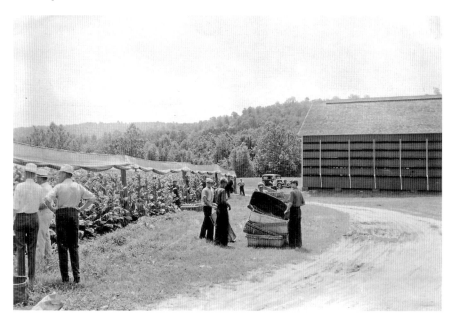

In the midst of harvesting at Tudor Holcomb's farm in West Granby, Connecticut, in 1935.

campaign heavily emphasized that machines made cleaner cigars, as seen in this drama-filled copy:

> *Spit is a horrid word. But it is worse on the end of your cigar...Why run the risk of cigars made by dirty, yellowed fingers and tipped in spit?*

Connecticut Valley Tobacco

Remember, more than half of all cigars made in this country are still made by hand, and therefore subject to the risk of spit![135]

In the 1930s, growers could make a lot of money if they were in the Shade tobacco business. The "shade" itself was one profit source for the Windsor Company. The company, led by John E. Luddy, shipped in thousands and thousands of acres of the cheesecloth material that became synonymous with the tobacco crop across the Valley. His distribution company dominated the cloth sales that Shade tobacco growers needed, manufacturing harder and more durable cloth to last the intense growing season. Even still, the cloth lasted for only about two years before it was too worn to be effective in the New England region. In order to keep the profit streaming in, Luddy would buy back the expired cloth for resale in the less rigorous climates of Puerto Rico and Cuba.[136] Luddy also promoted his cloth to grow flowers such as asters.[137] The "cloth" of tobacco tents remains in use today, although it is now plastic and more like a loosely woven tarp material.

Toward the end of the 1930s, a massive hurricane hit the Connecticut Valley, leaving $5 million in damage. The storm of 1938 tragically killed 125 people. It hit Hartford especially hard due to flooding from the Connecticut

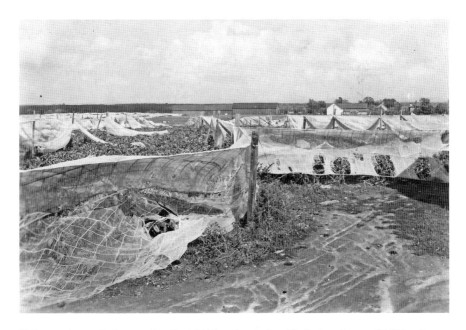

F. Ransom's wrecked tents after the 1944 hurricane. As with the hurricane of 1938, tobacco sheds were destroyed and netting shredded like spider webs.

River in the days before the hurricane landed. The event destroyed hundreds of tobacco sheds—flattening many. What tobacco, netting and sheds were not taken or mangled by the storm were burned. The winds knocked over the charcoal pans, used to aid curing, and lit sheds ablaze. Similar, but not as severe, storms would hit farmers again and again over the years, but the industry showed enough resilience to rebuild.

Tobacco production in the early twentieth century hit a peak so vast that it seemed that white tents filled with the plant were all that a visitor to the region would see.[138] Tobacco went through boom and bust cycles, but most definitely emerged strong. However, the culture surrounding tobacco was changing—who grew it, who worked it and who smoked it would continue to change throughout the remainder of the century.

To explore the tobacco history in the Connecticut River Valley in person, check out:

Salmon Brook Historical Society
Home of the Colton-Hayes Barn
208 Salmon Brook Street
Granby, CT 06035
Hours: Open every Sunday from June to September
2:00 p.m. – 4:00 p.m.
(860) 653-9713

Find out more at www.salmonbrookhistorical.org

5

SUMMER CAMP ADVENTURES AND CIVIL RIGHTS ROOTS

1940s–1950s

During World War II, the demand for American tobacco surged because of the disruption in the world's tobacco market.[139] State growers founded the Connecticut Valley Shade Tobacco Growers Association in 1941. In 1943, the federal government's War Food Administration determined that tobacco was a desirable crop to the troops serving overseas. In fact, the federal government considered tobacco essential to morale, at home and certainly to the men and women abroad. Tobacco was categorized as essential as bullets in the effort to win the war. In the mid-1940s, an impressive amount of tobacco was still being grown. About 17,800 acres of tobacco were harvested in Connecticut, in Massachusetts, 6,100 acres. Throughout the 1940s, growing cigar tobacco, curing the wrappers and processing the final product was a joint effort in that cigar companies sent a great deal of cured wrapper leaves down to the island of Puerto Rico for more grading. Cigar companies joined with partners in Puerto Rico in order to keep up with demand.[140, 141, 142, 143]

The war changed the Valley's labor force. Since so many American men were at war, women stepped into factory jobs. Agriculture, of course, also required a vast labor force to harvest. During the 1940s and 1950s, the Connecticut River Valley became a melting pot of tobacco pickers and sewers. Workers were local youths and adults of the Valley, male and female southern youths from Georgia, Alabama, Virginia, Pennsylvania and Florida, foreign West Indian or Jamaican workers and Puerto Rican pickers who were hired straight from the island beginning in 1953.

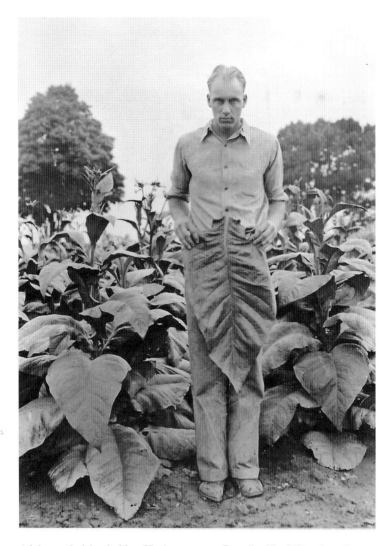

A labor technician holds a Hockanum-type Broadleaf leaf. Crossbreeding the perfect leaf was an ongoing process.

The year 1941 saw the birth of the Connecticut Valley Shade Tobacco Growers Association. Ralph Lasbury, the Shade Tobacco Association's farm labor coordinator, drew up a code for housing and sanitation in response to the appeals of Connecticut growers and workers for sanitary work conditions that plagued the 1930s. Concerns about child labor and adult migrant worker camp conditions prompted an "active public relations campaign" to protect the appearance of the tobacco farmers of the Valley. Lasbury

CONNECTICUT VALLEY TOBACCO

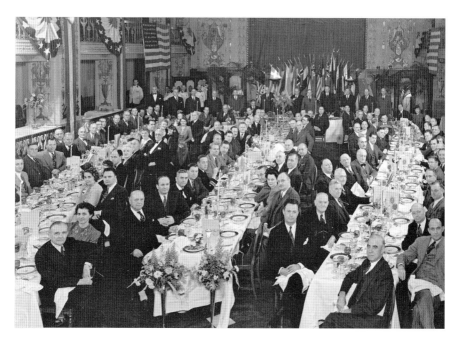

Dinner under the auspices of the Shade Tobacco Growers Agricultural Association and the Connecticut Valley Outdoor Growers Association in Washington, D.C., January 1949.

was actively changing public sentiment toward the tobacco industry with reforms and well-spoken words. He offered soothing slogans that highlighted the agricultural aspects of tobacco, affirming it was not an industry that worked people like machines. He painted an image of tobacco that was romantic, positive and all things American, which still holds meaning today. However, tobacco agriculture faced more challenges than he portrayed.

During World War II and the postwar years, the Valley required more workers than the southern colleges could provide. Lasbury secured a deal with the U.S. government and government officials of the West Indies to seek several thousand recruits from the West Indies to work on Connecticut tobacco farms. Three camps were established—one in Windsor, one in Stafford Springs and one in Portland. The men were recruited from all over Jamaica, many eager to go off to help the American war effort.[144]

The men who joined the work program left via ship to Florida, then made their way to Connecticut by train or another ship. The experiences that the Jamaicans had on board were nothing short of awful. The ships transporting five thousand men were deemed the "Hell Ship" and the "Starvation Ship." One passenger shared, "If anyone ever told you that we had three meals a

day on that ship, they were the biggest liars that God ever made."[145] Those who traveled on the SS *Washington* had much better treatment, since it was originally a luxury liner, when it was not under threat of being attacked by the Axis enemy lurking beneath the water. The men aboard did in fact get attacked by a German sub between Jamaica and Miami.[146]

The Jamaicans, like locals from Connecticut, stayed in wartime-inspired barracks. The dormitories were new, made especially for the new foreign laborers, which in part made up for the horrible passage from their homes. Besides beds, the living spaces had kitchens stocked with food, recreation areas and office spaces for the camp management. When they first arrived to New England, they had to endure the cold of early spring, unprepared for the climate.[147]

The days for the West Indians, and all tobacco workers across the Valley, were twelve hours long and often lasted six days a week.[148] One Jamaican described the work as "monotonous and tiresome, but it is far from being too strenuous for most of us." The main complains about the camps were the food. While the food was stocked up for them, it was not the food to which the men were accustomed.

In 1943, Lasbury and an old friend of his (a Florida high school principal) tapped high school students to fill labor needs. The trial group was a small group of boys, going as paid volunteers.[149] Over the next thirty years, the association bused girls and boys from high schools in Florida and Pennsylvania all the way up the coast to stay at camps. Florida girls became the face of the midcentury tobacco industry. They were young, full of cheer and all-American beauties.[150] For those decades, being a "Florida girl" had particular social status. The girls were out-of-towners with no strings attached. The young men of the Valley looked forward to their arrival each year, and it was not just because they were hard workers; they had a reputation for being hot dates for a night on the town.[151] It is interesting that the girls earned that reputation, but the Floridian boys did not. We can assume that much of the allure of working tobacco as teenagers was associated with summer romance on all sides. Reportedly, many young migrant girls would return year after year, often marrying local boys they met while working in the summer heat.

There was also a growing interest in child welfare in the tobacco fields that had carried over from the previous decade. The 1945 "Nine Little Girls incident" finally sparked child labor reform that had been an ongoing process of attempts at standardization since the 1930s. Nine girls, all of whom were African American and young—one only thirteen—went to work in July of that year as part of a day haul labor group. They were driven by bus to a

Photo taken at Thrall Farm in Windsor, Connecticut.

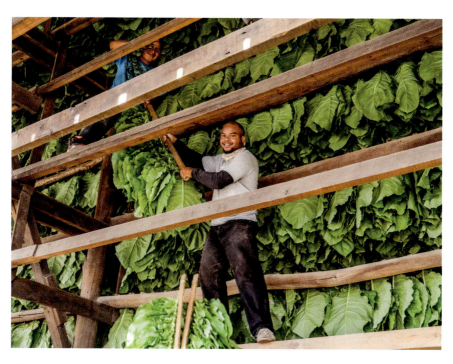

Hanging to Dry. Hanging laths in the rafters involves balance, not being afraid of heights and strength. Those laths get heavy!

This is what the pods of a Shade tobacco plant look like. The seeds themselves are incredibly small—like coffee grounds.

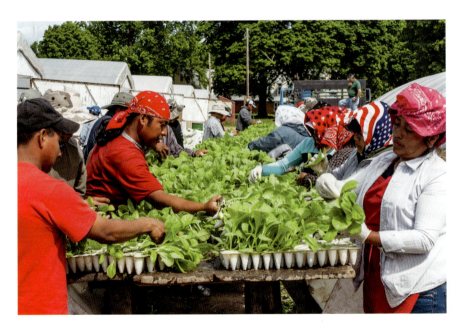

The plants have a long history of being started in seed beds until they are ready to be placed in the open fields.

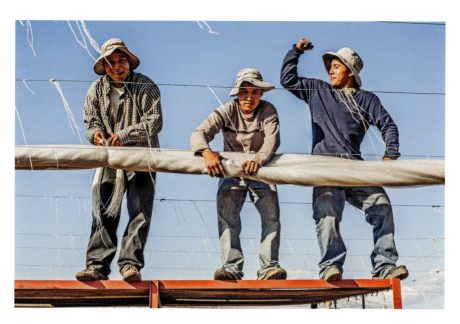

Three workers showing off and hamming it up while unrolling the plastic tenting material. The scaffolding they stand on makes securing the netting easier.

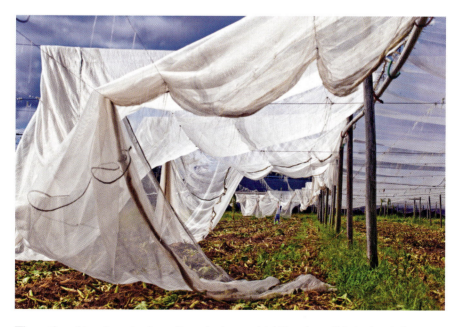

The netting, although made of a resilient plastic material, billows beautifully in the wind.

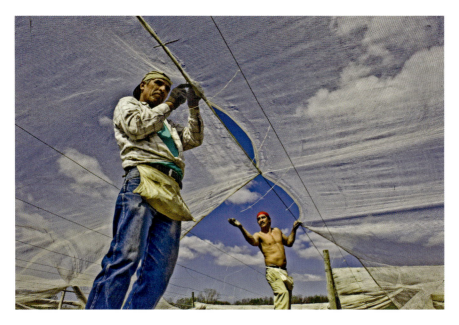

Securing the netting involves thick needles similar to typical sewing needles except thicker, as long as a finger and with a slight curve to them.

Young Broadleaf seedlings after being set and ready to grow in the fields by Day Hill Road in Windsor, Connecticut.

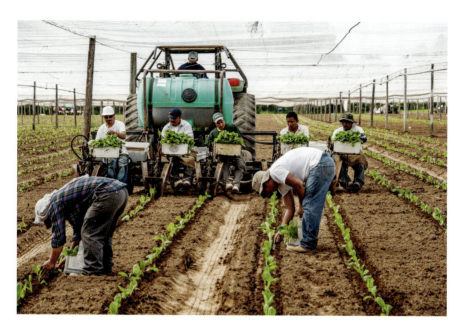

Planting the Seedlings. This is about as automated as cigar tobacco work gets. This setter has been rigged to carry six people.

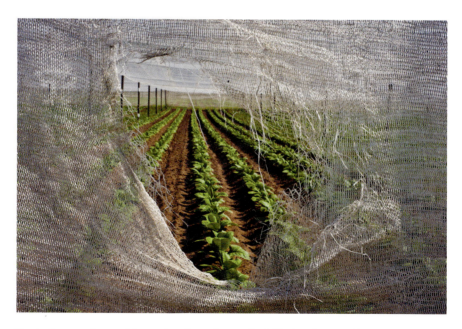

Peering into another world to peek at the early growth of Shade tobacco under the tents.

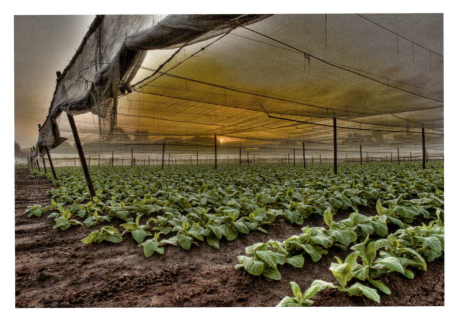

A sunset in the fields is an endearing sight. The side cloth on this tent was not yet covered.

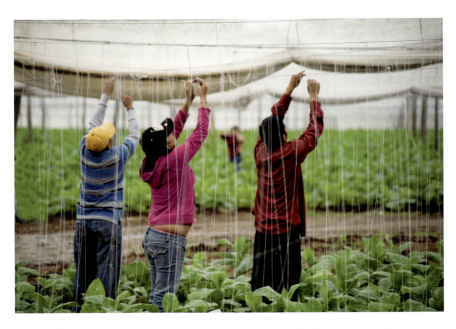

Stringing. Workers are wrapping string around the knee-high Shade plants that will then be connected to strong wire under the tent.

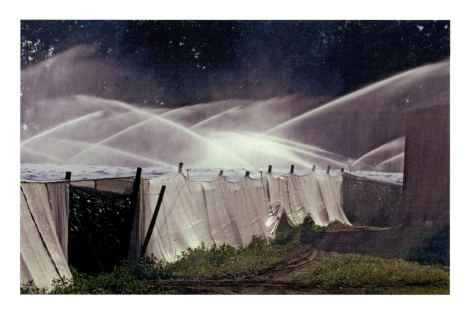

Irrigating. The netting is to keep the heat and humidity inside the tent to create a tropical environment the tobacco thrives in.

A sunrise in the fields is a promise of another day and more growth.

Tornado Aftermath. There is something about the Valley region that makes it a hot spot for tornadoes and hurricanes.

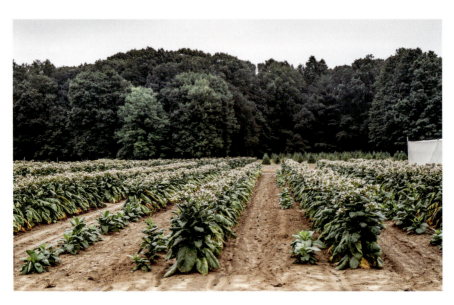

Broadleaf. Broadleaf is grown in full sun then harvested once at the end of the season with an axe.

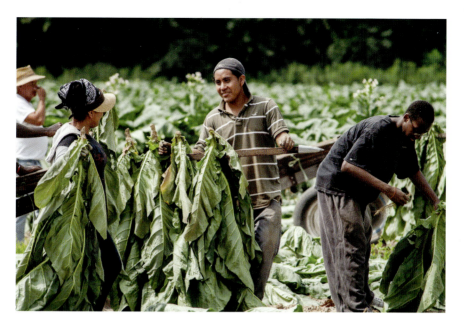

The tobacco is so delicate and valuable that a machine cannot be trusted to harvest the crops, even in modern times.

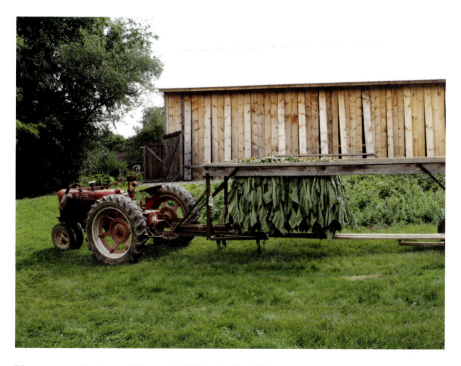

Havana on a rigging at a Havana leaf farm in Enfield.

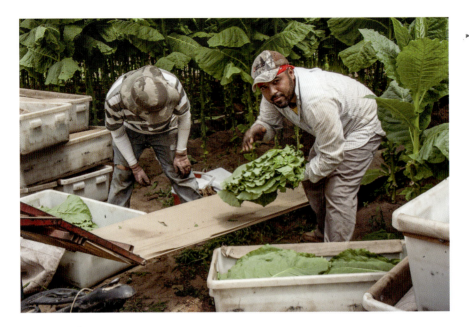

Packing. Harvested leaves cannot be pressed hard into the bins or stacked too high—that would damage the leaves, making them less than perfect.

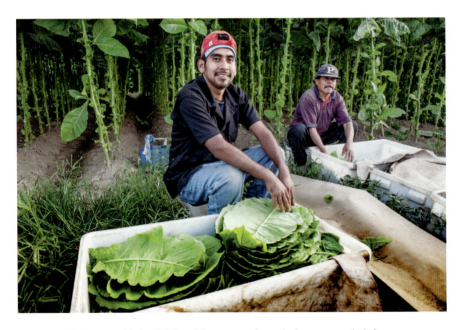

A picker grinning over his haul. The pickers scoot through the rows on their knees or backsides to pop off the ready leaves.

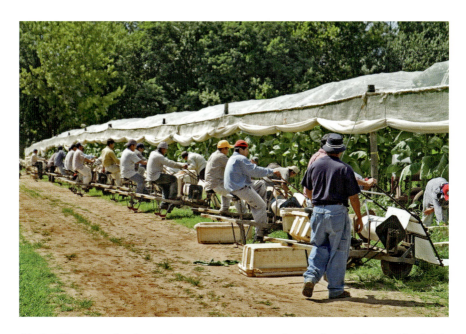

Bicycling. The unusual tools seen here are what appear to be a stationary bike combined with a wheelbarrow. In essence, they are.

Slats. A lath or slat is a thin, narrow strip of straight-grained wood on which the tobacco is hung and cured.

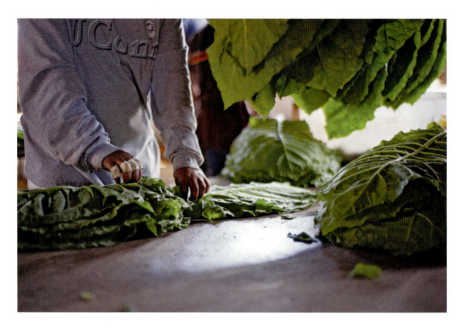

A sewing machine operator shows some local Huskies spirit while grabbing the fresh Shade tobacco leaves.

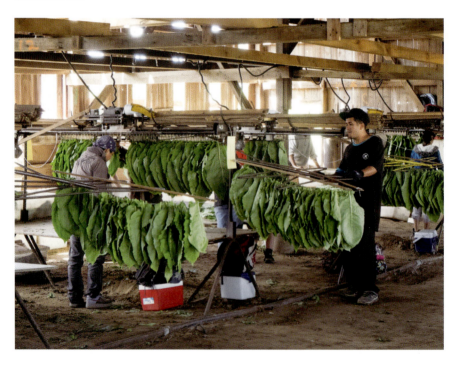

This tobacco is prepared to be hung. After the Shade tobacco is sewn onto a lath, it is ready to dry in the rafters.

Opposite bottom: *Drying Out.* Gas burners are used to regulate the curing process. Cigar tobacco undergoes an extensive curing process that takes weeks.

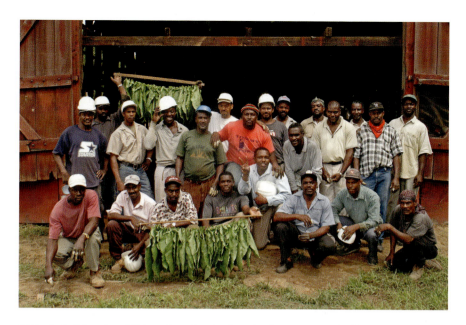

Worker Portrait. Jamaican H2A workers cheesing it up for the camera on the Brown Farm.

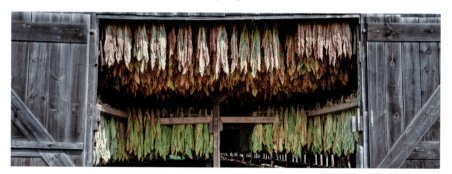

Hanging Out. Broadleaf drying in an open shed.

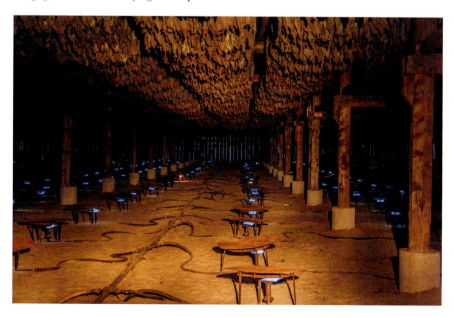

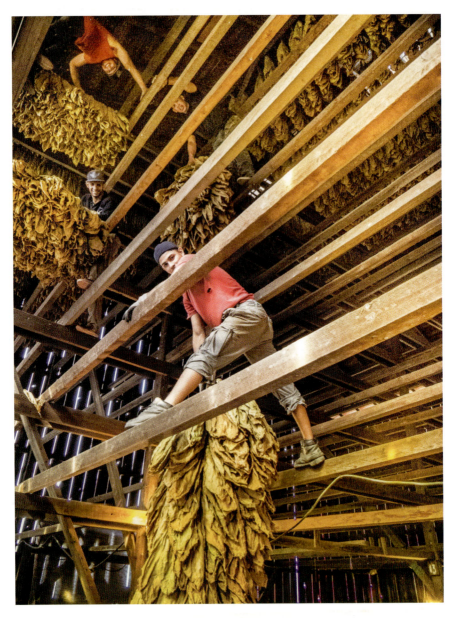

Taking Down. After curing, the Broadleaf is ready to be stripped. Stripping is the very beginning of the sorting and grading process.

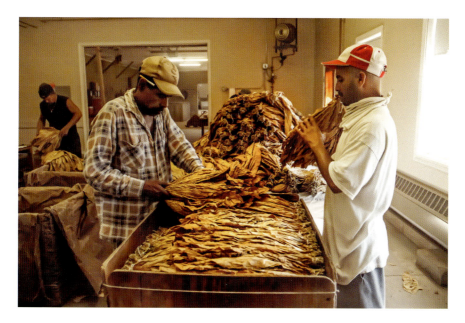

The leaves here have been cured and sorted by quality grades designated by size and color. The leaves are then wrapped into hands.

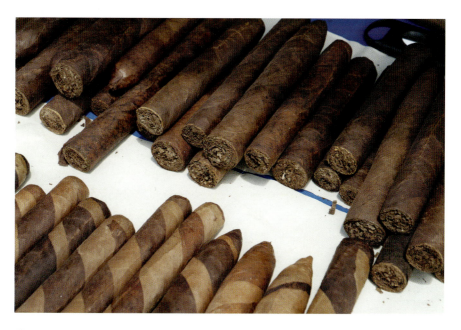

Cigars. The ultimate accumulation of all the skill, persistence, luck, science, and years of fine tuning… a bunch of lovely cigars.

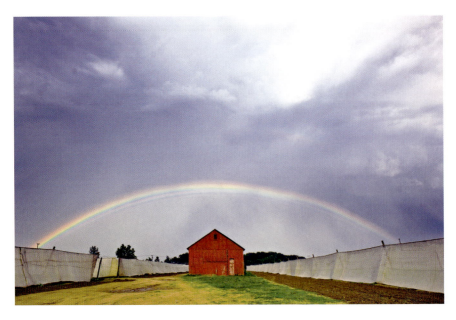

Rainbow Over the Fields. Taken just in the nick of time to catch the magic of the Connecticut River Valley.

A fallow field is synonymous with the end of an era. But the history in the soil and in the people will carry on.

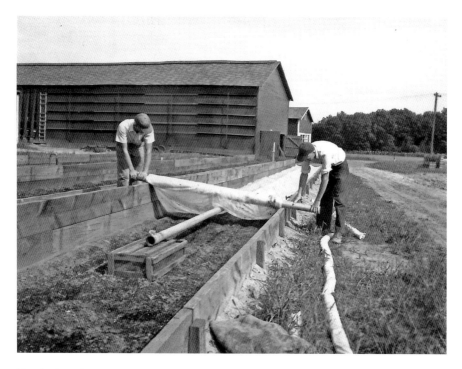

Fumigation of seed beds with methyl bromide in October 1950. Methyl bromide has not been used since it was found to be detrimental to health.

tobacco field some distance from Hartford. They were recruited with the understanding that they would be employed in a tobacco shed. When they arrived at the field, they were told to work in the pelting rain. They did this until they were thoroughly drenched and then got back on the bus because they desperately wanted to go home. The driver told the girls, "Of course you're not slaves so you don't have to work if you don't want to."[152] The teens had to walk eleven hours over twenty-ones miles home to Hartford. They had to seriously medicate their feet, ankles and entire bodies because of the raw weather they walked through.

Of course the story has two versions. Another paper published an article on the sad case that was less critical of the bus driver. In it, the bus driver told a self-serving, valiant tale about how, when he learned that one girl was thirteen, he refused to let her work. He further claimed that he could not drive them home because the company banned unscheduled rides.[153] The bus driver's story did not fool everyone. The glossing over of the driver's racist remarks in the article angered people. Many concerned citizens of the region reacted to the trauma that the girls went through by pushing for

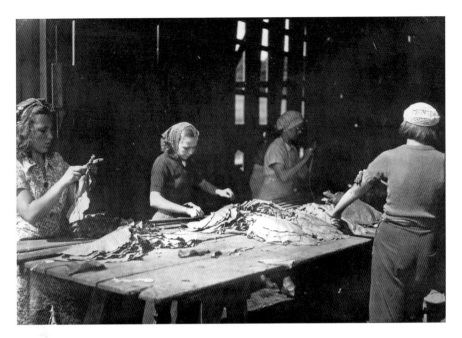

Women sewing leaves by hand at A.A. Clark's farm in Windsor, Connecticut, July 1937.

age limits on agricultural workers. To this day, anyone seeking to work in agriculture has to be fourteen.

The hiring of tobacco laborers in 1943 was an organized frenzy. Growers brought up forty-five Kentuckians and housed them in old Depression-era CCC barracks that were open in West Stafford Springs, Connecticut. The A.N. Shepard Company hired twenty-two Chinese immigrants who were living in Boston. They were a hard find because the labor needs in the state of New Jersey offered higher pay, so most Chinese agro-workers had gone to aid in the wartime effort there. The Chinese who came to Connecticut lived in barracks on the Shepard farm in West Suffield.[154]

One advertisement posted at the time shows the dire need that the tobacco industry had for laborers in the 1940s:

> 1,000
> *Tobacco Harvest Workers Needed at Once.*
>
> *Men – Women*
> *Boys – Girls*

You can help save the Connecticut tobacco crop by taking jobs on Shade Tobacco Farms immediately, Good wages paid, Safe transportation provided to and from the farm on modern buses or specially equipped trucks.

Factory workers laid off by cancellations--- Earn money until you are called back to your regular jobs.

No boys or girls under 14 years of age will be hired. Youths 14 and 15 year of age must furnish proof of age. Birth or baptismal certificates acceptable. These jobs open on farms operated by members of the Shade Tobacco Growers Agricultural Association.

...

Apply Monday Morning[155]

One local girl joined in the rush to help the war effort by pleading with her parents to allow her to work as part of the Civilian Women's Land Army (CWLA) based in Bolton, Connecticut. The CWLA was considered a prestigious corps; even First Lady Eleanor Roosevelt had come out to visit the camp in 1943. In 1944, when this fifteen-year-old joined, the CWLA was teamed up with Hartman Tobacco for the labor shortage. The lasting memory she recalls is what the boss told the teens: "'Tobacco has to be BABIED, BABIED, BABIED. It has to be TENDED, TENDED, TENDED. It has to be WORKED, WORKED, WORKED.' And work we did." She said her patriotic calling got her through the long days and left her feeling that she had learned about commitment and achieving goals.

Child labor reform was not the only social rights movement to be acknowledged nationally. The civil rights movement had stirrings in the Connecticut River Valley thanks to the Jamaican men who were brave enough to take a stand. An old former tobacco picker shared one of his stories of this social steadfastness:

Prejudice was there, we did not go out of our way to experience it. Most of the people did not know anything about black people. There were a few African blacks around before we came, but they did not mix in the suburbs too much. There was no television and communication was limited, so many whites never saw a black person before us. Many of the discrimination barriers were broken down by us. For example, there was a state theater called the Strand.

They did not want to admit us, but we showed up in force, sometimes ten to fifteen of us, and demanded they let us in. After a while there was no more problem in us going to any theater. The Americans (blacks)

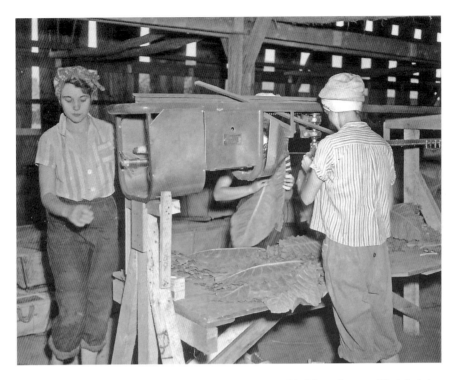

Women at a Shade sewing machine near Lake Congamond in Massachusetts. Their hair is tied to keep the sticky tobacco sap out of their locks.

were scared to challenge these places, but because we had numbers of us who traveled together, we were not afraid. The people were also aware that we were here working for the government and our behavior was always commendable.

The restaurants were the same thing. I did not experience this, but I heard that in the bars, when you went in to have a drink, the bartenders would break the glass when you left. The men found out about this and then they would go in a restaurant in a busload. They would all order drinks. Each person would order drinks for the group. When the owners found out that they were breaking forty to fifty glasses a night, they stopped the practice.[156]

Southern high school students traveled north to the Valley, as previously described, before and during their college summer breaks. Between 1941 and 1976, over twelve thousand high school students were bused north to work for the Hartman Tobacco Company. The young men who picked tobacco

stayed in camps in Manchester, and the young ladies stayed at a camp in Windsor, Connecticut.[157] These youths sometimes went on to do great things in their lifetimes. One such young man was Martin Luther King Jr.

Every American knows the name of Martin Luther King Jr. His name goes hand in hand with advocating equality and the civil rights movement led by leaders like him and Malcom X, albeit with different approaches. What many people may not know is that King worked as a young man under tents in Simsbury, Connecticut. Since he was only a teenager at the time, there are scant records of his time working in tobacco for Cullman Brothers, Inc.[158] The letters King would write home to his family still show the experiences he had while he was away at the camp earning money for Morehouse College. He was amazed at how he and friends could go anywhere they wanted to eat, sit where they wanted to sit and have pleasant interactions with the white people.[159]

King, as with anyone who has ever worked tobacco, considered tobacco labor to be grueling. Regardless of how hard his two summers of 1944 and 1947 may have been, King's autobiography claims that his time in Connecticut working tobacco was "eye-opening," especially being able to attend church and enjoy the same restaurants as the white folks.[160] The point of view was different for the young African-American tobacco pickers in the 1950s:

> *It was hard labor, you got paid almost nothing. But I almost felt like—as an African American person I didn't have the opportunity of my classmates, who got summer jobs working at some of the retail stores or working at some of the factories...I knew that I had to get an education and have something that I could offer an employer to have a decent job, because just competing with my [white] classmates, I wasn't getting anywhere.*[161]

Other stories have happier tales of adventure, hard work and lessons learned. A Connecticut River Valley woman wrote of her time as a fourteen-year-old working in Southwick, Massachusetts, for Spear Tobacco Farm, which was a subsidiary of Consolidated Cigar Company. Her weekdays were long, hot and humid during the summers of 1955 and 1956. She was a local girl, so she was walked each day to her designated farm.[162] During her two years, she earned 37 cents per each bundle of 50 laths. The money was acceptable, especially for a teenager. She knew that the faster she and her peers moved, the more they would earn, since pay was tied to piecework. Her story of earnings well saved is heartwarming:

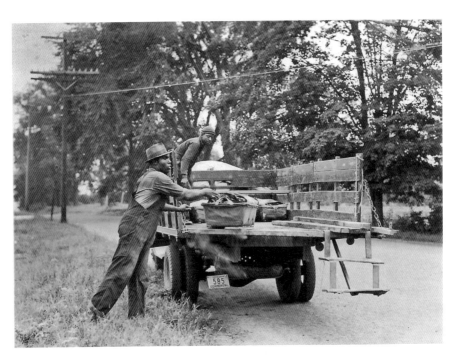

The loading of Shade leaves onto trucks at R. Clark's farm in July 1989. The Shade tobacco is being placed into the cloth-lined baskets.

> *My average weekly salary was about $42, which I signed and turned over to my mother. In turn, she would give me $5 for myself, to pay for school bus tickets and whatever else I wanted. The remainder was to help the household. Not bad for a 14 or 15-year-old!...The biggest surprise about those summers did not come until seven years later, when my mom accompanied me to buy my wedding gown, which she paid for with the money she had saved for that purpose from all my paychecks back in 1955 and 1956.*

Another fifteen-year-old African-American teen from Virginia described his free days filled with bus trips to Hartford and visiting shops. On the final weekend, he and his fellow campers were taken on a special end-of-summer trip to the Riverside water park in Agawam, Massachusetts, now known as Six Flags.[163]

The industry patented new inventions in an effort to make the Shade tobacco process easier. Most of them were in vain, since the tobacco is so delicate that it requires a human touch. In 1955, the total acreage in Connecticut was 14,700—6,100 of that was Shade tobacco alone. Massachusetts had 6,700

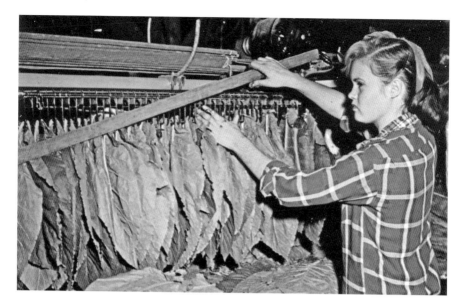

A sewer readying a lath for the next rack of Shade tobacco in the 1960s.

acres total, with 1,900 of those acres consisting of Shade.[164, 165] This was a substantial amount of leaf to be produced and processed.

Frank Landis, a buyer out of Pennsylvania for Bayuk Cigars, saw a need to improve sewing machines for the women who worked Connecticut tobacco. The Landis Portable tabletop tobacco sewing machine that the buyer designed and patented was used during the 1950s in place of sewing tobacco leaves in barns with large table sewing machines that would frequently catch the fingers of the girls who operated them. The Landis Portable created mobile workspaces that sped up the pace of large tobacco sewing machines while protecting the fingers of the women who worked in the sheds. The Landis machines were used for a time, but the large table-sized sewing machines are still in use today, albeit with better safety precautions.

The 1950s were a challenging time for Connecticut Valley agriculture, especially after the 1953 invention of the homogenized wrapper, an artificial cigar wrapper that blended ground up "junk" tobacco and leftover leaves into a paste mixed with adhesive and flavor. This paperlike tobacco was devastating to the Connecticut Shade tobacco economy due to the cheapness and ease with which it could be made. In modern decades, the homogenized tobacco leaf, known as HTL, is a mixture of chopped scrap tobacco and a cellulose adhesive, which is extruded into a sheet that can be cut in any size. They can be produced faster than handmade cigars, the likes of which are

found in convenience stores rather than high-end cigar shops. Machine-made or mass-market cigars are sold in the billions of units annually, compared to hundreds of millions for premium, handmade cigars.

The good intentions and higher wages were not enough to make local people want to do agricultural labor. Southern high school and college students were still being bused up during the summers, but the students began to be less available when new job types became available to them. Another new workforce came to the Connecticut River Valley in 1952. A new, uncontrollable workforce was the answer—Puerto Ricans. In a 1952 article, the *Hartford Courant* announced plans to officially "order" three hundred Puerto Rican farm workers on a trial basis to make up for the lack of available local labor. Another *Courant* article at the time stated that those from the island were "not compelled to return to Puerto Rico when they finish their jobs, nor are they subject to deportation if they break their contracts."[166]

Citizens from Puerto Rico had been in the New York and Connecticut River Valley prior to 1952, but the cultural and economic results of further migration would be seen in the 1960s.

The glory of the era and extent of the cigar tobacco enthusiasm in the Valley was encapsulated by the early 1950s Cigar Tobacco Harvest Festivals. For a few years, the blowout festivals were held to celebrate the successes of the end of the season. The festivals were big affairs involving block parties, scenic farm tours, international dance performances and even a seventy-four-mile riverboat marathon race on the Connecticut River. Each year, the ceremonies

Cigar tobacco pride permeated local culture. In the early 1950s, the Cigar Tobacco Harvest Festival was held to celebrate the end of the season.

This page from the 1952 Cigar Tobacco Harvest Festival program displays just a fraction of the local young women who competed to be Tobacco Queen.

centered on a Tobacco Queen pageant—the girls competed by town as well as ethnicity.

Tobacco agriculture was such a fascinating venture at that time that, not one, but two novels centering on the dynamics of friendships, hard work and

CONNECTICUT VALLEY TOBACCO

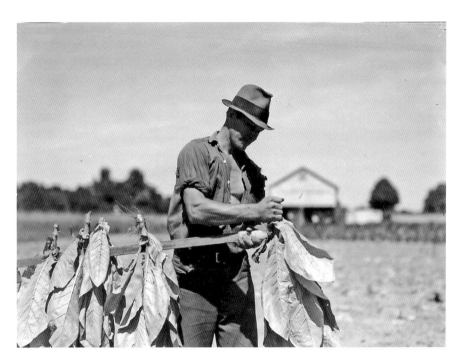

Field worker spearing the harvest of Havana seed tobacco, 1938.

even passion were published to capture the essence of the culture. *Parrish*, by Mildred Savage, was for adult readers. Published in 1958, it tells the story of a young man named Parrish who came to work as a tobacco laborer and fell in love with not one, but three girls, all the while stuck between a power struggle of two tobacco farm owners, portrayed as aristocratic tycoons. The book, and the classic movie that followed it in 1963, are highly dramatic.[167] The novel *Parrish* and the movie released with the same title must have paved the way for a book for young adult readers, *World of Their Own*, written by Laura Cooper Rendina. The four very different main characters from Florida go through the summer with lessons learned, a hint of adventure, teenaged angst and, of course, end-of-summer romance.[168] Both *Parrish* and *World of Their Own* capture the warm and fuzzy feeling of nostalgia that is associated with the twentieth century.

World War II and the Cold War era saw profitable times. Aside from the unfortunate failure of the invention of the homogenized cigar wrapper, the cigar tobacco industry held its own as America expanded its interests abroad and in industry.

Connecticut Valley Tobacco

To explore the tobacco history in the Connecticut River Valley in person, check out:

The Connecticut Valley Tobacco Museum
Home of the Gordon S. Taylor Tobacco Shed
135 Lang Road
Windsor, CT 06095
Hours: Wednesday through Friday 12:00 p.m. – 4:00 p.m.
Saturday 10:00 a.m. – 4:00 p.m.
(860) 285-1888

Find out more at www.tobaccohistsoc.org

6
CHANGING TIMES
1960s-1970s

When conjuring up images of the 1960s, most people think of hippie communes, long hair, marijuana smoking, drugs, the Beatles and the birth of the modern feminist movement and the modern environmental movement. In the world of farming, race and gender had a lot to do with how workers were treated. The local white students were treated the best, then the African-American college students and the other southerners, then women from Florida and Pennsylvania. The Latin-American workers of the 1960s and 1970s were treated so poorly that the legacy of poor treatment haunts today's modern tobacco agriculture. Things were changing fast, and as the counterculture questioned the establishment, public awareness of health problems associated with tobacco were part of that change.

The first hit to the cigar farming industry was the surgeon general's warning of 1964. The official report warned that tobacco was proven to cause cancer and likely related to chronic illnesses such as bronchitis. This was a blessing to the people who needed to quit smoking in order to remain healthy and still is a steppingstone for the research into cancers caused by nicotine and other carcinogens. However, to the cigar tobacco industry, this of course came as a blow. There was a brief upturn out of this economic devastation—in the 1960s, cigars were deemed slightly better for consumers than cigarettes.

The second change was a national policy with global impact. The sanctions set in place in 1962 firmly blocked any means for the nation of Cuba to thrive in global trade in order to pressure the overthrow of the United States'

Cold War enemy Fidel Castro. The embargo proved to be of some benefit to Connecticut's cigar tobacco industry for a period of time. By the mid-1960s, the U.S. Department of Agriculture reported an increase in the purchase of Connecticut's Broadleaf tobacco once they could no longer get leaf from Cuba.[169, 170] The third change to impact Tobacco Valley came late in the winter of 1964. Congress repealed Public Law 78, which effectively severed the ability of farmers in the United States to use foreign labor. The repeal aimed at ending the hiring of hundreds of thousands of Mexicans in America's southwestern region, but it also removed that "controlled labor" force. This action responded to complaints of abuse toward the Mexican workers and objections that foreign workers were occupying jobs that Americans could do if they were given the proper pay and opportunity.[171] It is crucial to view the 1964 repeal of Public Law 78 dilemma of agriculture in relation to racial tensions. This means that from the repeal came concern of labor availability, funding to keep up an industry that was in decline and concerns over the new wave of immigrants who could go wherever they wanted. The repeal exacerbated the overall race and cultural changes regarding agricultural labor and what type of person would do it. After World War II, while Americans were swooning over improved home appliances and cars, the tobacco farms once again needed to acquire a workforce to do stoop labor. Stoop labor, or any labor associated with backbreaking agriculture, was considered an undesirable job for Americans.

The repeal of Public Law 78 had far-reaching consequences. The alternative tobacco workers, Puerto Ricans, were legal citizens of the United States. This would seem to be to the benefit of the growers, since they were exactly what the government had intended when it repealed the law, to give Americans more job opportunities. However, in New England it made the cultural apprehensions of the people of Connecticut apparent. The tobacco farm owners, or growers as they are also referred to, and the members of the local community did not want to have an influx of migrant workers that could not be controlled by the regulations of short-term labor contracts. In 1965, the newspapers were filled with calls for local workers and updates on the recruitment process in Puerto Rico. "Another ten flights for a total of about 2,500 workers, is expected by the time of peak demand. This doubles the use of Puerto Ricans in the tobacco fields." Sadly, white locals considered Puerto Rican pickers foreign, even though they are legal citizens of the United States. Newspapers and oral histories from the 1950s and 1960s are used to prove that neither the tobacco growers, nor the local

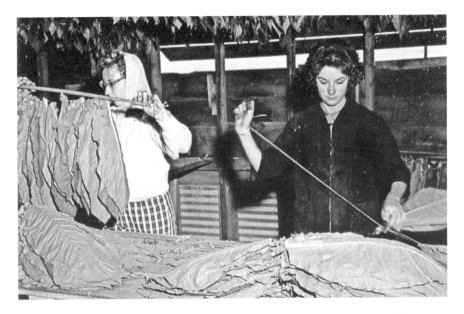

Sewing machine operators sewing some tobacco by hand and passing a lath in the 1960s.

people of the Connecticut River Valley, welcomed the new Puerto Rican workers, largely due to racism based on ignorance of them as a people.[172]

The American Southwest was a problem area of labor abuses to braceros, agricultural migrant workers from Mexico. The bracero program was a program that provided labor to agricultural settings in the southwestern United States when European immigration was going through stricter regulation. From the 1940s through 1964, the bracero program utilized temporary Mexican guest workers to do labor Americans were not willing to do. When it became undeniable that there were wrongs being done to the Mexicans in the Southwest, action was finally taken. Instead of pursuing justice for the abused, the 88th Congress, believing that higher wages for Americans and removing foreigners from agricultural work would bolster the economy and perhaps the American society, decided to terminate Public Law 78. The users of braceros were put on notice that this supply of foreign labor was cut off.

A release was put out by the U.S. Department of Labor that explained the repeal and why it was happening in 1964. The Department of Labor's secretary, W. Willard Witz, revealed that there were serious complaints about the hundreds of thousands of imported foreign workers being paid low wages and mistreated. The Department of Labor stated that accumulating evidence indicated the four million American men and women who needed

jobs would be willing to do the same agricultural work if they were paid a living wage to make the job appealing. The users of bracero workers in the Southwest had their labor cut off and all non-American migrant workers had to leave by December 31 of that year. This included British West Indians in Connecticut.

As with the issues of the 1950s in Connecticut regarding poor Puerto Rican treatment, when the abuses to braceros came to light, they were shared by non-farmers who wanted to help. In the Southwest, "conditions maintained by some of the growers have been so bad that church and civic groups and labor organizations have protested bitterly."

The announcement from the Labor Department's secretary went on to establish that the "commitment to…end poverty in this country would not permit a decision that we bring in workers at wage rates below the $1.15 to $1.40 range [about $2,500 for a full year's work], before offering at least that amount to domestic workers." This meant that, across the nation, agricultural labor wages would be raised by 20 percent so that American workers would be interested in working stoop labor—so that foreign workers would not have to be hired. This basic improvement to pay on the government level upset farmers—they believed the elevation of wages would lead to higher prices for farm products. Connecticut Valley tobacco growers found themselves caught in the backlash of migrant labor reform laws aimed at exploitation of Mexican workers in the American Southwest.

A national 20 percent wage boost was mandated to more than 20,000 Connecticut Valley residents working in tobacco, costing tobacco growers about $6 million a year. Immediately, newspapers across Connecticut began running articles about the effects of the repeal. The stories had predictions like, "Connecticut's tobacco farmers may have trouble getting enough workers this summer, even with increased wages." Valley tobacco farmers were dealt a sudden lack of controllable foreign labor and a pay hike to entice local workers, a situation that was beyond their decision to influence since it came from the federal level in response to the abuses of Mexican workers in the southwest. The farmers and the growers' associations were not fools, and none of them believed that local, domestic labor could meet all the needs of the growing and harvest seasons.

The higher costs of labor meant that there would be higher product prices in years to come. Legally, the Connecticut Valley growers had to prove that they were implementing the minimum wage of $1.40 an hour before they were allowed to be certified as usable. The laws on minimum wage were set to protect all agricultural laborers, yet a total consensus across the Valley

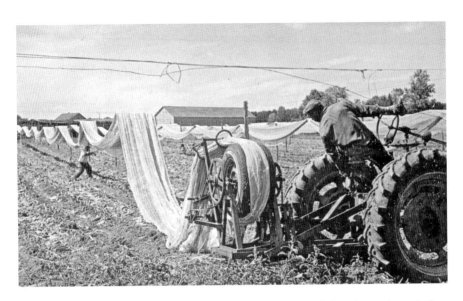

A tractor and a custom-made device pulls the shade netting off of the wires at the end of the season, circa 1960s.

was that the changes due to the repeal would actually reduce the number of local laborers instead of creating renewed interest. Across the region that meant an estimated increase of $6 million out of the growers' pockets. The Shade Tobacco Growers Agricultural Association was concerned, with good reason, that the future would see a wider use of homogenized cigar wrappers instead of real Connecticut wrapper. Along with that fear they also foresaw that tobacco acreage would drop by half in two years. The negative backlash from the repeal was reverberating across the Valley.

Ralph Lasbury Jr. gave insight into the growers' reasons why the British West Indians were the preferred labor source when local domestic labor was not enough to cover the needs of the harvest. A report was given in 1952, around the time when Puerto Ricans were first brought in from the island, that spoke directly to the sentiment of growers in 1965 as well. He said that in 1947, the Shade Tobacco Growers Agricultural Association worked with the state labor department to select a foreign labor source that would be most beneficial to the tobacco growers in Connecticut. "BWI project was picked, he said, because it offered the local growers a 'controlled' work force. By 'controlled,' Lasbury said, he meant the workers could be supervised and bound by immigration regulation so that any person causing trouble to the community or creating a problem could be immediately sent out of the country and barred from re-entry." In the 1950s, that labor program

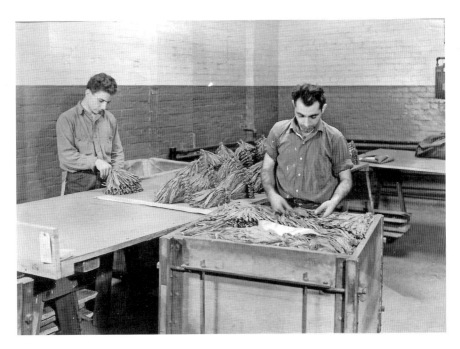

Men bailing the sorted Shade tobacco into a finished shipping case, 1937.

had between fifteen hundred and two thousand British West Indians in the Connecticut Valley at peak season.

The repeal of Public Law 78 removed that "controlled labor force" from the tobacco producers. The mad scramble for labor outside of Connecticut speaks to the changing views of what youth in the 1960s thought was good work. The good intentions and higher wages were not enough to make local domestic people want to perform agricultural labor. Even with the incentive of higher pay and a guaranteed job working tobacco, local kids still were not interested. They wanted town jobs, not stoop labor. This sentiment was confirmed in an interview with a Windsor resident who was a farmer during this time. He said that labor was consistently getting scarcer each year, as the times had changed. The local kids "went out to work for places like McDonalds and they had other part time jobs as the towns were hiring a few here and there. The labor source kind of dried up so we had to pretty much depend on all Puerto Rican labor." When the farmer spoke of the labor that they used on his tobacco farm over the decades, he said,

> *Until 1965 we had Jamaican labor, from the island, who came up on a four year contract. They were good workers, very conscientious workers.*

Connecticut Valley Tobacco

> *In 1965, they all had to go home because the government's position was that you had to hire U.S. citizens. In 1966, we had to bring everyone in from Puerto Rico under contract, a short term contract, and actually most of them were good workers although…They wanted to work maybe three of four days a week where your Jamaican worker would work seven days a week because they wanted that money to take home at the end of their contract. But, we got along. We still raised our crop of tobacco and harvested it.*

Laborers hailed from elsewhere in the Caribbean. The British West Indians, also known as Jamaicans, had been commonplace in Connecticut Valley for tobacco farms and apple orchards. In the early 1950s, in addition to the recruitment of Puerto Ricans, there was still a population of just over one thousand Jamaicans in the Valley area who stayed in New England to staff the tobacco warehouses through the winter months, packing and shipping.

The same 1950s newspapers that painted the prospects of Puerto Rican labor as an unfortunate necessity supported Jamaicans as the preferred source for foreign labor but portrayed the young white American workers in an even better light. In order to supplement the local day-haul labor, tobacco growers would annually set up youth camps for teenaged and college boys and girls brought into Connecticut from other states, and the camp program was somewhat enlarged the same year that the Puerto Rican connection was established in 1952. That year, "the total camp enrollment, including farms that place orders independently of the Association," was raised higher than usual.

Around the same time, there were new reforms in Puerto Rico that sought economic changes, bundled as a program known as Operation Bootstrap. Operation Bootstrap promised economic development on the island, which in reality meant that manufacturing companies, mainly from the United States, went to Puerto Rico after being promised both tax breaks and cheap labor. The hang-up was that the companies that went to Puerto Rico did not provide the economic boost in the way that had been expected by the residents. There were not enough jobs to truly stimulate the island's economy. It became clear that Puerto Rican men, who often already had extensive agricultural experience, including tobacco growing, needed jobs, and the Connecticut River Valley needed tobacco workers, so the arrangements were made. One of the most dramatic chapters in the 1950s and 1960s for residents of the Connecticut River Valley was the drama surrounding the condition of the Puerto Ricans that had been hired in 1952. At that time, about six hundred

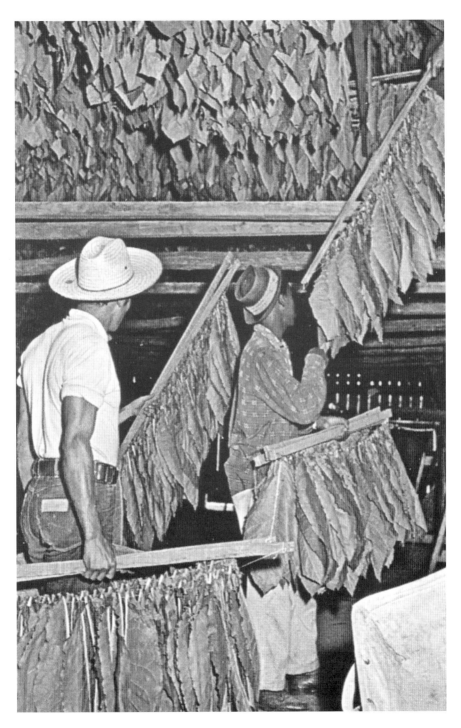
Men using teamwork to pass laths far up into the beams of a shed in the 1960s.

Puerto Ricans were living in and around Hartford. Poor housing conditions were being reported and the "Connecticut Council of Churches, a Protestant group, and a Catholic social center" asked for investigations into the living and working conditions of the migrant workers. There were also accounts of "'predatory farmers' who paid low wages and work them too many hours in violation with the law."[173] This was a chilling reality. The civil leaders calling for change said that workers were placed in housing that was shack-like, with no sanitary area, running water or even a kitchen to prepare their own food. Some did not even have beds. It was reported that complaints to local health authorities were falling on deaf ears.

One representative for the rights of the migrant workers asserted it was the farm managers who handled hiring that were the worst offenders against the well-being of the summer workers. Those conditions forced the Puerto Rican workers to quit and move to the city, seeking housing and employment there. This, in turn, was a burden to the welfare system. He said some of the migratory workers, faced with these conditions, broke their work contracts and moved into the city, causing a burden on the welfare load. He said the worst offenders were the managers in charge of crop pickers, not the tobacco farm owners.[174]

The owners of the smaller and family-oriented Broadleaf farms ran their operations very differently from the often-corporate Shade farms. Broadleaf growers often put their workers into actual houses for the summer and treated them with more dignity. Larger cigar manufacturers who ran Shade tobacco farms as though they were a division of their businesses were notorious for this behavior, and representatives from various associations actively suppressed negative press. The corporate companies were known in the 1960s and 1970s for having treated everyone that worked for them, particularly the migrant workers, poorly.

The Puerto Rican workers of the 1960s had a rough time—rougher than any other group before them. Their contracts were frequently abused by the corporations, which worked them far over eight hours a day, sometimes seven days a week, and overtime was not an option. This work with almost no break time during the week was a far cry from the luxuries that migrant workers received in the 1930s, 1940s and 1950s. As for their housing and food—it was docked from their pay at a far higher percentage than other workers over the decades. The men slept in overcrowded barracks with unreliable access to heat, drinkable water and even functional restrooms.[175]

During the 1960s and 1970s, across the country, labor standards rose due to the reactions in other fields, such as the coal and chemical

Connecticut Valley Tobacco

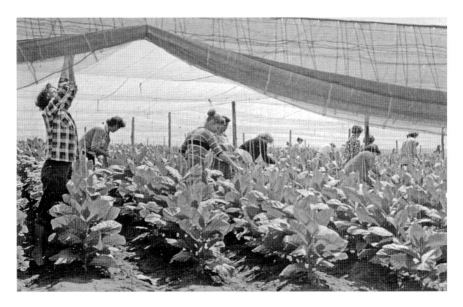

Women tying wires around young tobacco plants. This secures the plants and allows them to grow fully straight in height, 1960s.

industries. Social and union activism pushed for legislation on health and safety, and nationwide changes were made. The growers saw what had been happening on the farms, most of which were the larger, corporate farms—the small, family farms were and are better known for treating their hired help like family—and made efforts to better house and care for their staff. In 1970, Congress "increased government protection [of] American workers...created the Occupational Safety and Health Administration, or OSHA, to enforce national levels of safety for owners and workers." In that same year, Congress passed the Environmental Protection Act, which in turn led to the creation of the EPA.[176] These acts have helped tobacco farmers and their employees ever since be safer and more in tune with the environment.

The repeal of Public Law 78, while aimed at solving problems associated with the American Southwest and the abuses to braceros, clearly had an effect on the tobacco growers of the Connecticut River Valley. It put in motion an unstoppable pattern of events that both actively changed the way the Tobacco Valley operated and exacerbated existing issues of racial tensions. It must be known that most of the tobacco growers, especially family-operated businesses, sought to treat their workers well, regardless of the surrounding sentiments of some local people.

The *ABCs of Tobacco Stringing* was given out in the 1960s and 1970s for using big sewing machines made by the M.A.B Machine Corporation.

Connecticut Valley Tobacco

One man who worked at the Cullman Brothers, later called Culbro, farms in Simsbury, Connecticut, from 1965 to 1968 shared his story. Workers like him were almost the last of a kind. He was a local who started at the mandated minimum wage and worked his way up through various jobs in the fields until he was a paymaster.

> *I started when I was fourteen years old for the summer at $1.15 an hour. I started in the fields and when the Field Boss found out I was a local, he elevated me to "Straw Boss."*
>
> *The next year I came back and worked in the "Sheds" as a "Leaf Getter." That was fine with me…I got to work with the girls…Florida and Pennsylvania girls. The next year, 1967, I got my license and was able to drive a truck. Culbro had fields all over the valley. You never knew where you were going to be working. Sometimes fields were far away from the sheds. Then I became an assistant shed boss…that got me in with all the girls and the guys in the field hated me.*
>
> *I remember every 4th of July we would lose a shed by fire. Tobacco in its "curing" stage was cured by Propane Bunsen burner type of units. Sometimes leaves would fall on the unit and ignite—quite the sight…but very costly to the company.*
>
> *In 1968 was the last season of my career in tobacco I was a timekeeper, which afforded me to go all over the "Valley." I went to fields, I went to camps, in general I was paymaster. The cooks at the camps treated me very well. All in all, my early life in tobacco was some of the greatest times. If I could do it all over again, I would jump at it in a heartbeat.*

All in all, the 1960s were *not* a booming time for tobacco growers. The entire region that had once boasted forty thousand acres of tobacco in the 1920s was down to only nine thousand in 1960 and went on to lose another thousand during that decade. Even in the mid-1960s, for growers of "both Connecticut Valley shade and Broadleaf binder tobaccos, the long-run market outlook [was] one of great uncertainty."[177] The vast labor needs of tobacco growing continued to be a challenge. In the 1970s, there was a striking drop in acreage due to the homogenized wrapper cutting into the demand of quality leaf, urbanization of the flat farmland and increased production costs. The Shade acreage had only started in 1966 because it held its own even after the homogenized wrapper hit the market. Yet, by 1977, Shade had dropped, followed by another decrease in 1979, with a production area of four thousand acres

Connecticut Valley Tobacco

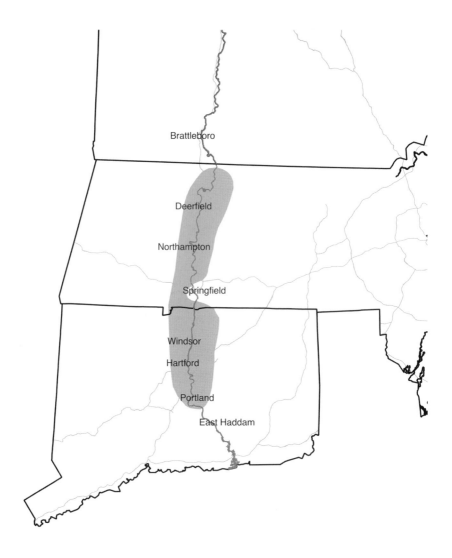

The region of tobacco cultivation in the Connecticut River Valley in the 1970s. *Map by Connor Brooks.*

of Shade, Broadleaf and Havana combined. The rapid suburbanization of rural regions on the perimeters often occurred due to middle-class city residents "fleeing" the cities in the 1970s and a growing population. Open fields and scarred woodlands became rows of ranch-style homes all over the Valley. One report in 1980 concluded, "Cigar tobacco culture is no longer the dominant type of agriculture in the region, nor is it even characteristic of the Valley's agriculture."

Many changes in economics and politics, Vietnam and the hippies, a growing population and mounting health concerns over nicotine, carcinogens and cancer shifted the entire nation's cultural dynamic. That shift included a step away from smoking. Even the embargo on Cuba, which was an international affair, symbolized a culture that put an end to threats, health or Communist, as best they could. At the close of the 1970s, the land development offers were practically being thrown into the laps of tobacco farm owners. With the pressures to sell and local cultural changes, the offers made to landowners from developers were difficult to refuse. Tobacco acreage dropped from nearly nine thousand acres in 1960 to only about three thousand in 1979.[178] The economics of suburbanization and the health awareness associated with the surgeon general's warning had slowed down the once unstoppable cigar tobacco industry.

> To explore the history of tobacco in the Connecticut River Valley in person, check out:
>
> **The Wood Memorial Library**
> 783 Main Street
> South Windsor, CT 06074
> Hours: Open Monday and Thursday 10:00 am – 8:00 p.m.
> Also open by appointment.
> (860) 289-1783
>
> Find out more at www.woodmemoriallibrary.org

7
THE NINETIES BOOST

1980s–1990s

By the 1980s, fewer local youths sought manual labor for income. They sought indoor summer jobs that provided air conditioning or were even encouraged by their parents to seek work that would look good on a résumé. By 1987, even the summer camps that housed out-of-state Florida, Pennsylvania, Georgia and Alabama students were discontinued. In addition to a fading labor force and subsequently higher labor costs, tobacco farmers faced higher taxes, fertilizer costs, fuel prices and interest rates.[179] Cultivation fell in the 1980s. The rate of farms selling land to developers or switching to alternate crops was so high that, in 1987, a group of farmers and scientists formed the Connecticut Valley Tobacco Historical Society to preserve the history literally disappearing before their eyes.

Valley tobacco production fell in 1992 to roughly 650 acres of Broadleaf and 720 acres of Connecticut Shade tobacco.[180] It would be a surprising savior, a magazine, that came to the industry's rescue by launching a craze of cigar interest the likes of which had not been seen in years. Cigars had been associated with the bad guys for a few decades. The publication that saved the day was *Cigar Aficionado*. The publisher of *Cigar Aficionado* sold a lifestyle statement heavy on class, resorts, whiskey and masculinity. The magazine made smoking cigars look like the height of what it meant to be a successful individual.[181] Just one year later, there was an indication that advertising had saved an industry that had been in another historic slump. Since the early 1990s, premium cigars, emphasis on the premium, have gained popularity in jumps and spurts for various reasons in the trend that the magazine set. The

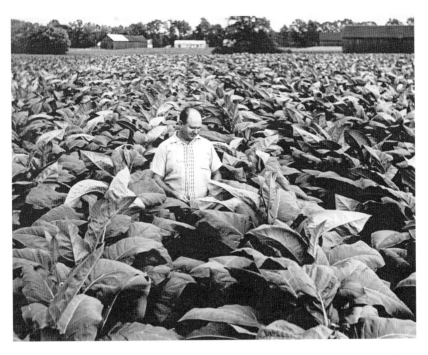

Broadleaf tobacco farmer F.M. Lutwinas surveying his Enfield, Connecticut crop in the 1970s.

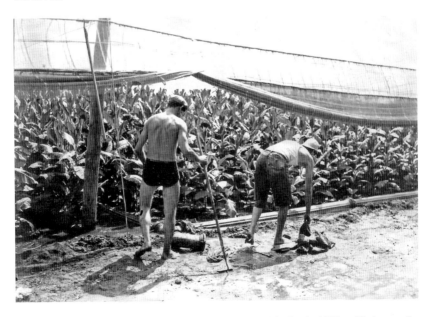

Workers irrigating in bathing suits and bare feet on a July day in 1939 at Hatheway & Steane in West Suffield, Connecticut.

timing of the magazine's launch may have had an impact on its popularity—at the tail end of the recession. So, if people had money to spend, they could exhibit it by flaunting a sexy smoke. An additional plus was that smoking a cigar was a way of behaving "slightly naughty" in response to nonsmoking laws being successfully passed around the nation.[182]

In the mid-1990s, Connecticut Shade tobacco grown in Massachusetts or Connecticut cost about $23,000 an acre to grow and cure, but that shocking number proved worth it when it garnered a price of $40 a pound. In 1993, Shade covered 850 acres. The next year, cigar consumption saw the first increase in sales in twenty-four years, which farmers in the Valley were certainly keeping up with. General Cigar spokespeople reported that their sales rose tremendously—from $73 million in 1992 to $87 million in 1994—and continued in a pattern like this throughout the rest of the decade. In 1995, they harvested about 1,900 acres of tobacco, after which a huge jump was seen in 1996 to about 3,000 acres of Broadleaf and Connecticut Shade.[183]

In 1997, the rush to get in on the boost in cigar popularity had farmers from across the Valley gearing up for a new wave of tobacco cultivation. The most incredible part of the rush was that some of the farmers had never even grown tobacco on their farms before. Some may have had family who grew tobacco a few generations before, but others set aside their usual crop or tilling up land that they had resting. Farmers who did not usually grow tobacco used what they could. Old sheds that had been cow barns for years were transformed into curing sheds, a sod farmer raised eighty acres of tobacco and vegetable growers planted tobacco in whatever lots they could. Farmers did this to boost revenue on the land they already owned; buyers for the cigar companies were buying all the tobacco that they could. As the smaller operations prepared, so did the large corporations that owned land and leased it to farmers to grow, such as Culbro Tobacco. When the demand was that high, Connecticut Shade tobacco was valued at $37,500 for fifteen hundred pounds. The only limit to how much could be planted was whether a grower also had shed space to cure the tobacco. After all, half the magic of a good Connecticut River Valley smoke comes from the advanced curing that the leaves undergo.[184]

With cigars the "it child" of the '90s, Connecticut Valley growers were not the only ones feeling the burn of sudden demand. In America, growers of filler and binder leaf also raised more tobacco to meet the market's needs. Cigar manufacturers in the Dominican Republic placed phone calls to the growers in the United States, trying to get all the tobacco they

could. The frenzy was even cause enough to prompt illegal behavior by cigar smokers who wanted to get their hands on cigars made in Cuba. In 1996, the U.S. Customs Service had to confiscate almost one hundred thousand cigars from fourteen hundred attempts to smuggle cigars from the communist-controlled nation.[185]

Cigar popularity hit a peak around 1997 due to the intense advertising of the cigar lifestyle. Celebrities such as Whoopi Goldberg, Demi Moore, Danny DeVito, Jack Nicholson and Arnold Schwarzenegger were seen

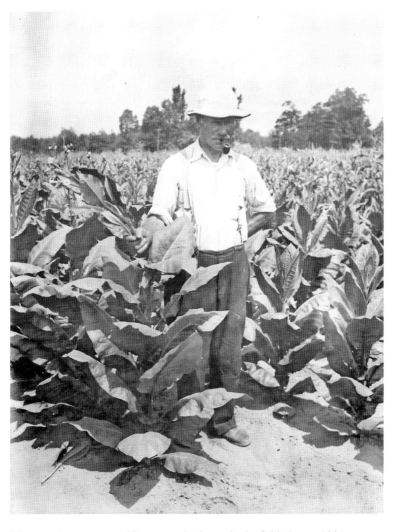

Man topping sun-grown Havana seed tobacco in the field, August 1934. Topping a tobacco plant means breaking off the flowers that start to bloom.

with cigars and talking about how they made them feel. The lifestyle with which one was supposed to associate cigars was that of glamour, masculinity, sexual prowess. The advertisements featured women posed suggestively with a stogie, as if to say, "If you smoke this brand you will have this in your life." It made cigar buyers feel good. Any American could feel that way, too—with a good cigar. At the close of the 1990s and moving into the new millennium, the cigar craze had calmed slightly but still plateaued at a much higher level of consumption in decades.

The reason for the plateau was most likely twofold. First of all, no craze lasts forever—the business moguls and celebrities had their cigar limelight, but then smoking cigars became normal by the end of the decade. Second, with the intense demand on cigar companies there came some quality glitches. The crux of the matter lies in the demand being high and the supply of finest cigar tobacco being low, so some cigar companies sold cigars that were not the highest possible quality, resulting in a pullback in sales. By the time that the demand evened out in the early 2000s, the cigar business was still far higher grossing, but without the intense consumption of a decade past.

To explore the tobacco history in the Connecticut River Valley in person, check out:

Historic Deerfield
80 Old Main Street
Deerfield, MA 01342
Hours: Open April through December 9:30 a.m. – 4:30 p.m.
(413) 775-7214

Find out more at www.historic-deerfield.org

8
CUBA REOPENS
2000s–2010s

The modern world is a globalized world. Most people experience the results of globalization every day with their smart phones, international job possibilities and the boundless power of the Internet. The globalized world has allowed for greater swapping of information, politics and ideas. Some of the most interesting ideas that relate to today's cigar smokers and the future of the Connecticut River Valley revolve around feminism and health. The two words may seem like an odd fit, but they do work in regards to increased cigar consumption.

In the twenty-first century, the identity of cigar smokers changed again. While it was almost exclusively the wealthy and affluent who partook in the smoke in the 1990s, it was the rise of the Average Joe and female smokers in the following decades. Any woman or man could walk into a cigar shop after a long day and light up. In the occasional act of smoking, socializing and unwinding, the average person *feels* like a million bucks. For women, cigar smoking has emerged as a lifestyle and a choice, not merely a novelty. This is a fairly new concept. Men have dominated the cigar smoking realm almost entirely since its conception in America, and women have joined that group. While women posing with cigars were frequently only found in the folds of magazines, the number of women who genuinely smoke cigars increased impressively in the 2010s. Previously, it was rare to see a lady smoking a cigar in a cigar shop.

Greatly due to the powerful influence of the Internet, women have found forums of their own where they can talk about brands, tastes and preferences

without being fetishized. Women not being afraid to seek empowerment "make a stand by lighting up."[186] Some women are determined to start a feminist cigar movement based on notions of equality, while others just enjoy cigars and do not want to be hassled for smoking. Either way, the gender bridge in cigar smoking was crossed by women appreciating cigars' leaves and craftsmanship.

The craftsmanship that goes into cigars like Davidoff, Macanudo and Arturo Fuente brands need mostly two types of leaves from Connecticut—the Shade and the Broadleaf. Modern cigar companies seek two different aspects from them. In a simple sense, light and dark, but the subtle differences are what cigar smokers really look for. From Connecticut Shade wrappers a connoisseur looks for silky, velvety texture with a light golden-brown color on the wrappers. Their veins are almost invisible and they taste mild, much less spicy than other leaves. With Connecticut Broadleaf and certainly Havana leaf, a dark wrapper will also feel like velvet, but more textured than Shade. They can be rich, smooth and even peppery.[187]

Connecticut census data from 2012 reveals an interesting portrait of who the modern tobacco farm operators are as far as race, ethnicity and gender. The census reported that as of 2012 there were forty-nine with white operators, six farms with women as the principal operators and one with a Spanish, Hispanic or Latino operator.[188] The work they and their employees do involves fairly simple tools in a modern time. Many different crops around the world are harvested by machines—olives, oranges and apples can be vacuumed or even vibrated right off of their trees. Potatoes and corn are harvested by huge cultivators that have GPS, computerized monitoring systems and air conditioning in the cabs. Broadleaf and Havana tobacco is still chopped by hand with a hatchet, then allowed to wilt for an hour or so. The leaves are then speared onto a lath in the fields and taken by wagon to be hung by men climbing high into rafters. Shade tobacco is still picked carefully by hand and placed on thin tarp "carpets" so that it never hits the ground. The only hint of mechanism, if it can be called that, is the way in which the carpets are rolled up into a bike-like device at the end of the rows. This tobacco bike is one of the specialized tools that a tobacco farmer invented exclusively to improve production, which is a challenging thing, given that Shade tobacco is such a delicate leaf to handle.

Globalization has had a profound influence on Connecticut's tobacco product. In the national and global arena, there was no place that could produce the same quality of Connecticut Shade tobacco that came out of the Valley, due to the unique soil and weather combination.[189] This was

the case until Ecuador began planting Connecticut Shade tobacco; the plant invented in Windsor and crossbred for modern sustainability in the experimental station began being planted in the South American nation. This is a sore subject for modern tobacco growers. The seeds were taken to Ecuador because there was no legal protection for them. The plant does very well in the humid tropics of Ecuador and has been used as cigar wrapper for many years. It is marketed with names like "Connecticut Shade Tobacco, from Ecuador" and "Ecuadorian Connecticut Shade."

Despite well-documented health warnings about tobacco use, consumption of expensive cigars began to surge in the 1990s and was stable in the first ten years of the new millennium. In 2006, about one thousand acres of Shade Leaf were harvested, which made it the state leader of agricultural export in dollars, bringing in more than $30 million a year, according to the U.S. Department of Agriculture. Shade tobacco is the state's fifth largest agricultural commodity by volume. With that price tag, tobacco is one of the most expensive crops in the world to produce and the most profitable by a huge margin, even with shifting interests of consumers. In the years to come, the prediction is that there will be an upswing in the popularity of dark-leafed cigars, which means that sungrown varieties of tobacco will be in higher demand.

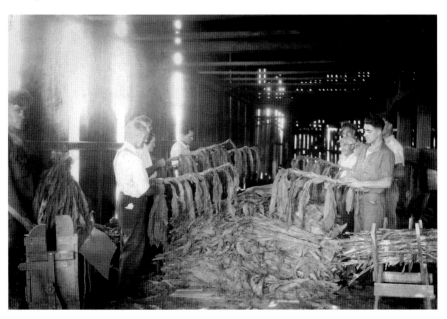

Stripping the tobacco from the stalk during a fall "damp" in September 1934. A damp is a humid fall day that naturally re-humidifies the tobacco.

From the farmers' perspective, the changes that tobacco growers face mount higher each year. Local teenagers are no longer interested, and their parents tell them to find jobs that will look good on college résumés. The farm owners have a hard time finding reliable workers in a climate of increased sensitivity to illegal labor. Today, not much is known about the identity of tobacco workers. The H2A temporary migrant workers from Jamaica, Puerto Rico and Latin America filled the gap left by the local teenage labor in the mid-twentieth century. Mexican laborers have worked for many growing seasons in the Connecticut River Valley as well. Workers in the tobacco fields are often Mexicans and other various Central and South American residents, who are legal migrant workers. Yes, growers are private about who they hire, well within their rights given the conflicted climate on immigration in America. For all workers, tobacco farmers provide housing, healthcare access and food. Growers also must pay for transportation and housing for workers from outside the country and are also legally responsible if they hire someone with false documents. A newer reality is that in the 2010s, even though papers are legally needed, there have been workers who do not sign labor contracts with their employers, meaning that they do not get the same protections as their coworkers with official documents.[190]

Jamaican workers remain the most commonly hired workers during the tobacco season. There are many dynamic factors in play that make Jamaican workers so common in the fields. First of all, they have been contracted for agricultural work in America since World War II, when the people of the nation were subjects of Great Britain. They speak English and Patois, which makes for easier communication. Puerto Rican workers have also been a steady group of people in the tobacco workforce; however, a study on tobacco workers in the 2000s found the following:

> *During the 2003 growing season, for example, one of the largest tobacco farms in the Valley employed 100 Jamaicans, and only 20 Puerto Rican workers, a significant decrease from the year before. As US citizens, many of these workers felt that they had the right to advocate for better working and living conditions, and were not reticent about bringing to the growers' attention unsafe or exploitative living and working conditions. However, as the international cigar market contracted, fewer of these workers were invited back, replaced by workers who were more dependent on staying in the good graces of the grower…Puerto Ricans' dependence on labor contracts, coupled with their limited facility in the English language and their overall low status relative to Jamaican workers, consigned them to the structural*

category of 'foreigners' despite their US citizenship. Moreover, the increasing number of Mexican workers without H2A visas in hand meant that they now had to compete with a Spanish-speaking labor force that was highly desirable to growers, since they were willing to work for lower wages.[191]

The history of tobacco cultivation is also a history of migrating workers of all ethnicities from all over the nation, Europe, Central America and the Caribbean. Their history has included a dynamic of fear and exclusion of the temporary migrant worker communities, and thus isolation felt by the workers. Locals still expect to see migrant labor, but once the workers leave a farm property, they get nervous about having the police called on them.[192]

Increasing concerns about environmental changes are also influencing the tobacco industry's decisions. Storms cause issues every so many years. The most recent storm that walloped the Valley was not a hurricane—it was a tornado. In 2013, a tornado struck the Connecticut River Valley on a Monday afternoon, tearing the netting away from a Connecticut Shade tobacco field and flattening plants that were almost ready to be harvested. The tornado, with maximum winds of ninety miles per hour, touched down in one place and possibly four others. Drivers on the roads witnessed large sheets of tobacco netting cast into the air like plastic bags soaring across the landscape. The tobacco netting from a field of Connecticut Shade was torn away and ended up strewn across trees, on power lines and on neighboring houses. It was a shock to tobacco farmers, who were in the middle of harvest season. The storm did not cause irreversible damage, thankfully. The damage looked worse than it was on the Thrall and General Cigar Co. fields, and they were able to recover the Shade fields and carry on the plants in surprisingly great shape.[193] During the growing season of 2014, the rough estimate of tobacco land in active cultivation was about two thousand acres total, with about seven hundred of those acres for Connecticut Shade tobacco.

At the end of that same year, on December 17, 2014, the United States reopened communications with the nation of Cuba, which the United States had cut off relations with after the Cuban Missile Crisis. Since 1962, the nation had been excommunicated by the Unites States.[194] Decades later, it was clear that the embargo failed to be a success because it was only truly harmful to the Cuban citizens. It had been an "old man's" political folly for some time. The antiquated reasons for the dark tradition of the blockade were examined and reassessed, finding that the time was right to open up some trade and travel to the nation that had more or less been stuck in a

time capsule. Since 2012, polls in the United States indicated that American citizens would prefer a more normal economic relationship with the small island nation.[195] The United States lifted the embargo that closed off the small island nation and re-staffed its embassies.

President Barack Obama issued an executive order that made travel to Cuba easier and, most importantly, legal. In March 2016, he became the first sitting president to visit the island in ninety years.[196] The major reason for opening up to Cuba was to aid the ordinary people , who have suffered for a lifetime while the embargo was in place. This new trade stage is very relevant to the cigar agriculture of the Connecticut River Valley and cigar manufacturers nationwide—after all, Cuban cigars are raved about across the globe.

The cigar enthusiasts in America had been waiting for the day when Cuban cigars could be theirs for smoking pleasure. Cigar tourism will likely increase 100 percent to the island, and consumption of Cuban cigars will become commonplace. Smokers will have to find out if the Cuban cigars are the best in the world or, if because they had "long been the forbidden fruit," that their reputation has added to the flavor. The cigars made in Havana have a worldwide reputation for excellence, which made them worth smuggling into the country. The interesting truth is that many American vacationers would get a thrill if they thought they were buying illicit Cubans while visiting the Dominican Republic or other Caribbean islands. But in most cases, the vacationers would be duped by clever locals who simply re-band or removed bands from cigars in order to pass regular cigars off as Cubans.

Today, consumers can enjoy "the real deal." Tourists to Cuba, who undoubtedly visit for the cigars, the cars and people, can now return to American soil with $100 worth of Cuban cigars. The new, but slow influx of Cuban cigars is less of a threat to the Valley agriculture now, but when Cuban trade is fully open, the results will be apparent.[197] This means change to come in the growing of Connecticut Valley Tobacco. Aides for government officials sent out feelers for how much tobacco was being grown in the state of Connecticut around the same time.[198] In the 2015 growing season, five growers stopped raising tobacco, but there is no clear proof that the reopening of trade with Cuba was the direct cause. It is a guess to say that the slow opening of Cuba is to protect the cigar tobacco farmers with a cushion in order to keep their agriculture strong.

The continued congressional and federal push to moderate all aspects of tobacco use have had a clear effect on the cigar tobacco industry, or

more specifically, the shrinkage of the allure of the tobacco products. Even President Obama, who smoked cigarettes on his campaign trails and a bit while in office, gave up his habit to lead by example. In 2009, Congress enacted the Family Smoking Prevention and Tobacco Control Act. In 2015, additional action flexed the power of the federal government's 2009 act to make it harder for the young to buy tobacco. In 2016, the Food and Drug Administration began seeking to expand what a tobacco product is under the Deeming Tobacco Products to Be Subject to the Food, Drug & Cosmetic Act, which cigar smokers oppose on the grounds that the FDA will have regulation abilities that, while aimed at protecting people from disease, greatly diminishes the ability of cigars to be categorized as different from a chemical-based e-cigarette or vape tools.[199] While it may appear to be a tight focus on health, blending of chemical-based "tobacco products" with premium cigars, these things are not the same. The impact on the cigar leaf growers could be one more hard hit that they do not need. And thousands of jobs would be lost in the Valley area. Congress is considering two pieces of legislation, H.R. 662 and. S.S. 441, to protect both the industry and cigar smokers. H.R. 662 was proposed but passed on to the Subcommittee on Health, while S.S. 441, which sought to amend the Economic Revitalization Act of 2011, was introduced but currently is being considered by the Senate.[200, 201]

The twenty-first century began to see a resurgence in concern over health standards for workers in tobacco fields of the Connecticut River Valley. The following studies on labor matter, because the very real health concerns associated with all tobacco consumption have had the longest and most irreversible effect on the tobacco agriculture of the Valley. Agricultural work does have health challenges, but studies reveal those to be less than public opinion might think. In 2005, a study from the *Agromedicine Journal of Medicine* revealed that tobacco workers, mostly Latino, were coming into clinics with symptoms that seemed quite worrisome. They were believed to have Green Tobacco sickness (GTS). A study was conducted, and they did not have increased nicotine in their systems. In fact, the Connecticut Shade tobacco has significantly less nicotine absorption rates into the skin than cigarette tobaccos, possibly because of the way that the leaves are harvested. The study concluded that the workers did not in fact have GTS, which was likely due to the methods in which cigar tobacco is handled while being harvested.[202]

An international rights watch group also contends that while working tobacco in the Valley is hard, it is certainly less of a health hazard than other occupations. The Human Rights Watch spoke with over one hundred young

pickers in their teens or younger working in the four states that produce most of the nation's tobacco—North Carolina, Kentucky, Tennessee and Virginia—and found that three-quarters of them reported symptoms such as vomiting, nausea, headaches and dizziness while working on tobacco farms, all consistent with acute nicotine poisoning.[203] However, in the Connecticut River Valley, acute nicotine poisoning is not an issue. George Krivda of the state Department of Agriculture reported in 2014 that in Connecticut's tobacco farming, the level of worker safety and stricter work rules are higher than agricultural standards.

The farmers and the state want healthy workers, especially since they are most often guests to this state. The conclusion offered by Krivda backed up an earlier report by the National Institute of Health. The National Institute of Health found in 2005 that migrant workers in Connecticut who harvest Shade tobacco "appear to have a low risk of occupational nicotine dermal absorption." That study said the Shade tobacco plant also may have a lower level of nicotine than either burley or flue-cured tobacco used in cigarettes. So, while working tobacco is very hard work, as generations of area teenagers can attest, it apparently does not make pickers sick—aside from the typical tobacco rashes from the sticky sap that effects new workers.

These studies show that since the 1970s, there have been active and ongoing efforts to improve labor conditions in the tobacco fields for both local and international workers. There is a group of students and professionals who travel to tobacco farms called the UCONN Students' Migrant Farmworkers Mobile Clinic. They work in part with the government of the state of Connecticut to check workers for standard health issues that may develop while they are here and cure diseases they may have arrived with, such as tuberculosis.[204] This work is a noble endeavor in helping the migrant workers who are a silent support system of many types of industries—not only Connecticut River Valley tobacco but across the nation.

In the sixteen years that the twenty-first century has unfolded, there has been greater globalization of tobacco labor in the Valley, more studies into what it is like to be a farmer and worker and more passion into the fine art of smoking by men and women alike. From 2000 to 2016, there were no major dips or highs in the cigar world; however, in the Valley it seemed as though development of the land was happening as quickly as the gains in the popularity of Ecuadorian Connecticut Shade.

Connecticut Valley Tobacco

To explore the history of tobacco in the Connecticut River Valley in person, check out:

The Suffield Historical Society
Home of the King House
232 South Main Street
Suffield, CT 06078
Hours: Open May through September 1:00 p.m. – 4:00 p.m.
(860) 668-5256

Find out more at www.suffieldhistoricalsociety.org

9

LIVING LEGACY IN THE VALLEY

PRESERVING TOBACCO HISTORY

From the original human cultivation of *Nicotiana rustica* to the height of the cigar tobacco agro-industry in the early and mid-nineteen hundreds, there was always a close association between increased production of the crop and labor and environmental pressures. However, the pressures on tobacco production in the Valley have shifted away from the internal demand of labor to support the formerly expanding industry to a series of interlinked external pressures that have led to nearly unstoppable shrinkage of acreage.

In the modern decades, the Connecticut River Valley is going through changes at a rapid pace, faster than ever before. The region of active tobacco farming runs from south of the city of Hartford, Connecticut, northward along the Connecticut River Valley on to Montague and Deerfield, Massachusetts. This stage in the history of cigar tobacco history here is certainly one of decline in a world of antismoking heath awareness, cultural shifts in types of popular work and the increasing value of land for commercial development.

The culmination of these factors has reduced the Connecticut acreage from a high of 30,800 in 1921 to approximately fewer than 2,000 acres in the 2010s. Fields that once grew tobacco now are planted with buildings that have been turned into industrial areas or housing developments. This means that efforts into land conservation, building preservation and expanded appreciation of the cigar tobacco industry matter now.

The region in focus, the Connecticut River Valley, also includes the sizable Lower Farmington River and Salmon Brook areas as well. The

Connecticut Valley Tobacco

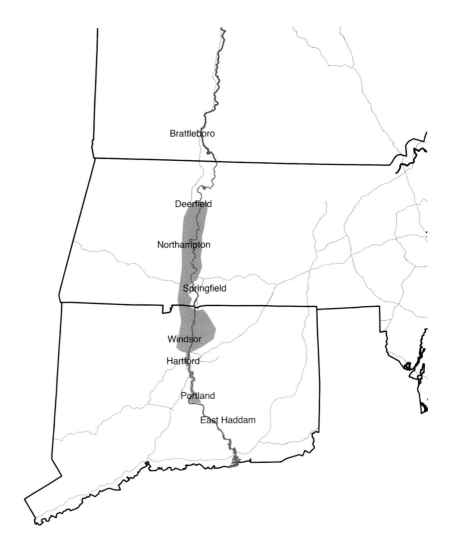

The region of tobacco cultivation in the Connecticut River Valley circa 2012. *Map by Connor Brooks.*

Farmington River and the Salmon Brook regions are certainly famous for ample historic archeological sites, homes and other buildings from the Native Early Archaic periods and the colonial period through the industrial era. The river and valley regions are all part of a patterned historical landscape—like a beautiful rural quilt. The landscape and its history make a cultural landscape, or geographical area that holds natural and manmade resources. As the human development of the region

increases, a greater focus must be placed on maintaining the sacred value of the remaining cultural landscape.[205]

Thinking of a cultural landscape can seem a tad dry, but imagine the rolling hills of farmland or the wooded, winding back roads that you have explored in your life. Recall that feeling of awe and bliss from taking in those sights and feeling secure that they are still there to return to. The feeling linked to the memory of the landscape is what preserving cultural landscapes is based on. The very reason for the driving tour locations in this book is to help readers get out to see the cultural landscape and the historic buildings in person in order to build an even more personal connection to the vivid history.

The secret to history is that it lies beyond the textbooks for most people. The ability to visit a region and location directly related to tobacco cultivation—touching the bricks of a factory that once hummed with the activity of cigar rollers and box makers, driving past the shade tents of Windsor to see the silhouettes of the pickers and walking inside of former tobacco sheds to see just how high a person has to climb to hang a lath—is invaluable.

Beyond that feeling associated with the cultural sites is the fact that history does not preserve itself. It is people who preserve the very land that we hold dear—and it is better to hold onto that land in real life than only in our society's collective memories. In the people there is also a form of human cultural resource—the farmers who have cultivated the land, the people who migrated to the Valley regions to work and the local people who have been living in and literally around the tobacco history.[206] It is a privilege to have such resources all around, and it must be remembered that the heritage is kept alive by active efforts to preserve the land and structures in it.

Quite often, tobacco farmers work the land in the same manner as their ancestors did for generations. Farming is a time-proven way of avoiding having the landscape carved up for building development by keeping it active. Even land preservation can prove tricky—it is wonderful to have land set aside for cultivation, environmental health and the benefit of sheer beauty, but it can prove difficult for families down the road with high taxes and few ways of stepping out of farming generations down the road.

The two states that still grow cigar tobacco, Massachusetts and Connecticut, do have recourses available and have made steps in putting at least one tobacco shed on the Connecticut State Register of Historic Places. More legislation and secure funding are needed to support farming families and the historical profession and increase the appeal of preservation. In the public sphere, residents of the region should be aware of the pressure to

Closing the sorted, delicately packed leaves into a bale for shipment. It took a few strong men to work the press.

develop the region and take efforts to help preserve the land's beauty in any way that they can.[207]

In the state of Massachusetts, the Land Trust Coalition engages in community conversation and with government and legislative groups and

land owners in order to directly save land.[208] Connecticut has both the Connecticut Land Conservation Council, which serves to actively preserve and care for conserved land, and the State Register of Historic Places, which ensures that structures and development projects are prioritized and carefully considered. Working with these organizations is the best way to start engaging with the preservation of the cultural landscape.[209, 210]

The raising of cigar tobacco in the Connecticut River Valley is a fascinating industry to think about. While it *is* absolutely an industry due to its size, global affiliations, economic power, cultural association and sheer landscape acreage, there is also something intangibly earthy and primitive about it. It is, after all, an agricultural endeavor. The workers labor with the earth on their fingers and sap in their hair, and the farm owners are always at the mercy of nature to decide their fate each season. After all, that is what the landscape of the region is, a cultural landscape that has been part of the community and national memory associated with tobacco—the heart and soul of the Connecticut River Valley.

The value of the past is clearly seen in the continued cultivation of the land itself. Farming the land and taking efforts to preserve land from the push of development are the bests ways to keep the history of the land alive in a visible way.[211] This is quite hard for many reasons, but in particular, there are threats to the Connecticut River landscape, which as readers and longtime residents know, has been rapidly developed since the 1980s. Valley towns get tax income from the sprawling complexes, so they are inclined to encourage businesses to build here. The biggest threats to this lush region are losses of farms to development, roads and buildings built through historic and archaeological sites, neglect and removal of historic homes, taverns and factories, removal of bridges with historic value and land development that has no care to respect archaeological resources.[212]

Preservation of the farm and wild landscapes of the country are not an old concept. National parks such as Denali and Yellowstone began as efforts to save the stunning landscapes that hold the environment in a safe balance. This effort has been renewed here because of the increased urbanization, or development, of the Connecticut River Valley. Residents of the region should be aware of the pressure to develop the region and take action to help preserve the land's beauty.[213]

One way of preserving the rich heritage of the cigar tobacco agriculture in the Valley is by repurposing tobacco sheds. The act of preserving an existing building can seem daunting to owners, as the tobacco sheds were specifically designed for one purpose, but the possibilities are expansive.

Connecticut Valley Tobacco

A city of sheds all in a line at a curing facility for American Sumatra Tobacco Company in the Congamond area of Massachusetts.

Valley experts on the ins and outs of tobacco sheds and their preservation Dale and Darcy Cahill suggest that they be used for weddings, since barns have once again become a popular venue for celebrations.[214] Sheds can have cement floors installed to make them into garages or adapted for use as chic cart studios or kennels for animal shelters. A more permanent idea is to have them adapted into apartments by modern building experts. Builders would be able to save money with the preexisting bones of the structure. Sadly, sheds are lost due to fire, storms, time and purposeful removal to avoid taxes. This disappearance is a "heritage in crisis." This is a silent heritage dilemma, but one that can be helped with understanding and education.[215]

Even the fallow fields themselves can be repurposed. The director of the experimental station in Windsor, Connecticut, has been able to reassure organic farmers that former tobacco fields are safe for re-cultivation. If farmers, particularly food-crop farmers, can reuse the land, the value will be retained financially and culturally. After all, the landscape of the region is in and of itself a cultural landscape that has been part of the community and national memory associated with the tobacco.

In conclusion of this brief history of tobacco agriculture, this article, written in 1948, recalls an unclear past:

> *I believe that its blood (the essence of the Connecticut Valley, so to speak) today undoubtedly forms a part of the hereditary set-up of the tobacco*

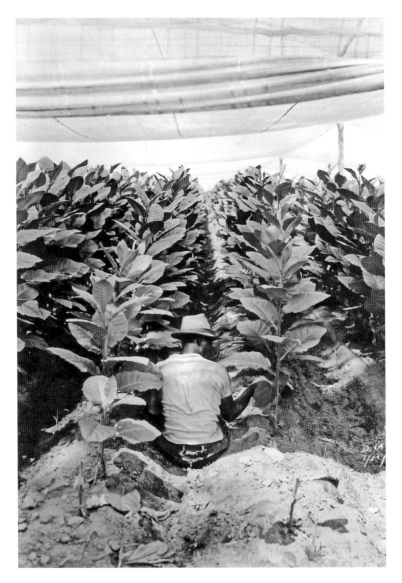

A man suckering Shade tobacco leaves from the stalks at R. Clarks's farm, 1941.

plants grown there. However, this cannot be proved, and local tradition has it that the Valley tobacco dates back to a package of seed found in some sea captain's attic. I mention this because the same thing has happened with other introductions, and the persons to whom credit is really due are forgotten.[216]

CONNECTICUT VALLEY TOBACCO

This sentiment observes that myth and tradition have a deep part in the cigar tobacco culture in the region. Never let it become a hazy, half-remembered tale like this. Remember the true history of the cigar tobacco in the Connecticut River Valley put down in these pages. The history of tobacco in this soil is long, diverse and filled with trials and plenty of tribulation as well as joy and celebration. In parting with this long legacy, take this with you for the future:

Once the land has had technology impressed upon it, there is no recapturing the precious essence of open space, and the timelessness, solitude and peace that can only be found within it. It is not that all development should be opposed, but that a balance should be maintained, so that farms will not be squeezed between shopping malls. The Connecticut Valley is beautiful, worthy of being preserved. If much is taken out of it, and none of it preserved, what will it give back to this population and future populations?

We come and we go, but land is always here. And the people who love it and understand it are people who own it—for a while.

Willa Cather

To have a fun family day on a former tobacco farm in the Connecticut River Valley, check out:

Brown's Harvest
Home of the "Hands-On" Strong-Howard House
1911 Poquonock Avenue Windsor, Connecticut 06095
Hours: Open May through October 10:00 a.m. - 6:00 p.m.
(860) 683-0266

Find out more at www.brownsharvest.com

NOTES

Chapter 1

1. Sean Rafferty, "Evidence of Early Tobacco in Northeastern North America?," *Journal of Archaeological Science* 33, no. 4 (2006): 453.
2. Ibid., 455.
3. Ibid., 456.
4. Ibid., 453.
5. Ibid., 456.
6. Ibid., 457.
7. Joseph Nicolar, *The Life and Traditions of the Red Man* (Bangor, ME: C.H. Glass & Co. Printers), 57 quoted in Howard S. Russell, *Indian New England Before the Mayflower* (Hanover, NH: University Press of New England, 1980), 148.
8. Lucianne Lavin, *Native Uses of Tobacco*. E-mail to B. Dunlap, February 24, 2016.
9. Christopher Columbus and Joaquin Miller, *The Journal of Columbus' First Voyage* (Washington, D.C.: The Inventors' Outlook, 1912), 21.
10. Josselyn, John. *An Account of Two Voyages to New-England: Made during the years 1630, 1663* (Boston, MA: W. Veazie, 1865), 179.
11. Ibid., 176.
12. Ibid., 181.
13. Robert K. Heimann, *Tobacco and Americans* (New York, NY: McGraw-Hill, 1960), 65.

14. Russell, *Indian New England Before the Mayflower*, 159.
15. Josselyn, *Two Voyages*, 111.
16. Ibid., 107.
17. Gregory Mason, "Native American Food," *Natural History* 37 (1936): 313, quoted in Russell, *Indian New England Before the Mayflower*, 158.
18. Russell, *Indian New England Before the Mayflower*, 159.
19. Mason, "Native American Food," 313, quoted in Russell, *Indian New England Before the Mayflower*, 158.
20. Russell, *Before the Mayflower*, 161.
21. Josselyn, *Two Voyages*, 60.
22. Ibid., 61.
23. Ibid.
24. Ibid., 62.
25. "Schaghticoke History," Schaghticoke Tribal Nation: The Official Website of the Schaghticoke Nation, http://schaghticoke.com/history/.
26. Lavin, *Uses of Tobacco*. E-mail sent February 24, 2016.

Chapter 2

27. Herbert Putnam, *Books Manuscripts and Drawings Relating to Tobacco from the Collection of George Arentis, Jr., from an Exhibit at the Library of Congress* (Washington, DC: Library of Congress), April 1938.
28. Paula Neely, "Jamestown Colonists Resorted to Cannibalism," *National Geographic News* (May 3, 2013): http://news.nationalgeographic.com/news/2013/13/130501-jamestown-cannibalism-archeology-science/.
29. Ibid.
30. Heimann, *Tobacco and Americans*, 67.
31. Charles McLean Andrews, *The Colonial Period of American History* (New York, NY: Henry Holt, 1912), 154.
32. Ibid., 155.
33. Ibid., 211.
34. Leah Glaser, Lucas Karmazinas and Diana Sheil, "Lower Farmington River and Salmon Brook Management Plan June 2011," Lower Farmington River/Salmon Brook Wild and Scenic Study (June 2011): 56.
35. Albert Van Dusen, *Connecticut* (New York: Random House, 1961), 20.
36. Thrall Family, "Our History" (Windsor, CT: O.J. Thrall Incorporated, 2014), 2.
37. Heimann, *Tobacco and Americans*, 87.

38. Connecticut General Assembly, *The Public Records of the Colony of Connecticut*, edited by J.H. Trumbell, vol. 1 (Hartford, CT: Brown and Parsons, 1850) 53.
39. Ibid., 146.
40. Michael C. DeVito, *East Windsor Through the Years: Bicentennial Commemorative* (Warehouse Point, CT: East Windsor Historical Society, 1968), 141.
41. Joseph Robert, *The Story of Tobacco in America* (New York, NY: A.A Knopf, 1949), 105.
42. W.B. Weedon, *Economic and Social History of New England* (Boston, MA: Houghton, 1890), 204.
43. J.H. Trumbell, *The Public Records of the Colony of Connecticut 1678–1689*, 205, quoted in Elizabeth Ramsey, *The History of Tobacco Production in the Connecticut Valley* (Northampton, MA: Department of Smith College Vol. 15 No. 3–4, 1940), 114.
44. Ramsey, *Tobacco Production*, 14.
45. Heimann, *Tobacco and Americans*, 84.
46. The Society of Colonial Wars in the State of Connecticut, "1643 Wethersfield," http://colonialwarsct.org/1634.htm.
47. John A. Stoughton, *A Corner Stone of Colonial Commerce* (Boston, MA: Little and Brown, 1911), 6.
48. Heimann, *Tobacco and Americans*, 85.
49. Ibid.
50. John Cockburn, *A Journey Over Land, from the Gulf of Honduras to the Great South-Sea* (London: Bible and Crown, 1735), 139. https://archive.org/details/journeyoverlandf00cock.
51. Ibid.
52. DeVito, *East Windsor Bicentennial*, 141.
53. Jack Jacob Gottsegen, *Tobacco: A Study of Its Consumption in the United States* (New York, NY: Pitman Publishing Corporation, 1940), 147, quoted in Heimann, *Tobacco and Americans*, 89.
54. Israel Putnam, Rufus Putnam and Albert Carlos, *The Two Putnams, Israel and Rufus: In the Havana Expedition, 1762, and in the Mississippi River Exploration, 1772–73, with Some Account of the Company of Military Adventurers* (Hartford, CT: The Connecticut Historical Society, 1931), 9.
55. Ramsey, *Tobacco Production*, 115.
56. Putnam, *Two Putnams*, 52.
57. DeVito, *East Windsor Bicentennial*, 141.

Chapter 3

58. National First Ladies Library and Historic Site, "First Lady Biography: Margaret Taylor," National First Ladies Library, http://www.firstladies.org/biographies/firstladies.aspx?biography=13.
59. Robert, *Tobacco in America*, 102.
60. Museum Archives, "Middletown Vol. 070 Part II" (Middletown, CT: Wood Library Museum Archives).
61. Wood Library Museum Archives, "Tour Fact Sheet 2013.04.085" (South Windsor, CT: South Windsor Historical Society).
62. Robert, *Tobacco in America*, 95.
63. Wood Library Museum Archives, "Tour Fact Sheet 2013.04.085"(South Windsor, CT: South Windsor Historical Society).
64. Leah Glaser, Lucas Karmazinas and Diana Sheil, "Lower Farmington River/Salmon Brook Outstanding Resource Values: Outstanding Resource Values: Historic and Cultural Landscape," Lower Farmington River/Salmon Brook Wild and Scenic Study (November, 2009): 19–28.
65. Robert, *Tobacco in America*, 95.
66. Ibid.
67. Patricia Oriorne, E-mail to B. Dunlap, March 11, 2016.
68. Ibid.
69. Oriorne, "Gillett Cigar Factory, Southwick," Southwick Historical Society via Community Preservation Coalition, http://www.communitypreservation.org/successstories/historic-preservation/292.
70. Heimann, *Tobacco and Americans*, 89.
71. Adrian Francis McDonald, "The History of Tobacco Production in Connecticut" (New Haven, CT: Tercentenary Commission by the Yale University Press, 1936), 7.
72. Ramsey, *Tobacco Production*, 153.
73. Clarence I. Hendrickson, "A History of Tobacco Production in New England," PhD. diss., University of Madison–Wisconsin, 1929, 66.
74. Town of Suffield, "History," Town of Suffield, Connecticut Accessed March 11, 2016. http://www.suffieldtownhall.com/content/10058/10064/default.aspx.
75. Ramsey, *Tobacco Production*, 129.
76. Rebekah Turnmire, "Tobacco in Vogue: Commercial Adaption of Connecticut Valley Tobacco 1860s–1901," Summer Fellowship Program Research Paper, Historic Deerfield, 2012, 8.
77. Hendrickson, "New England Tobacco," 16, quoted in Turnmire, "Tobacco in Vogue," 10.

78. Robert, *Tobacco in America*, 97.
79. Turnmire, "Tobacco in Vogue," 11.
80. Ibid., 12.
81. Heimann, *Tobacco and Americans*, 103.
82. Cassandra Tate, *Cigarette Wars: The Triumph of "The Little White Slaver"* (New York, NY: Oxford University Press, 1999), 23.
83. Heimann, *Tobacco and Americans*, 103.
84. Ramsey, *Tobacco Production*, 154.
85. Ibid., 141.
86. Peter Hardin, "Poles and Puritans," thesis, Hampshire College, 1975, quoted in Marla Miller, *Cultivating a Past: Essays on the History of Hadley* (Amherst: MA, University of Massachusetts Press, 2009), 273.
87. Ibid.
88. Turnmire, "Tobacco in Vogue," 11.
89. Ramsey, *Tobacco Production*, 133.
90. Turnmire, "Tobacco in Vogue," 13.
91. Miller, *Cultivating a Past*, 279.
92. Ramsey, *Tobacco Production*, 154.
93. Turnmire, "Tobacco in Vogue," 14–15.
94. Tate, *Cigarette Wars*, 23.

Chapter 4

95. Dale and Darcy Cahill, *Tobacco Sheds: Vanishing Treasures in the Connecticut River Valley* (Atglen, PA: Schiffer Publishing, 2013), 102.
96. "Tons of Fertilizer Manufactured Here," *Hartford Courant*, Print, January 24, 1915.
97. Hendrickson, "New England Tobacco," 118.
98. Ibid.
99. Ibid., 113.
100. Connecticut Agricultural Experiment Station, "The Growing of Tobacco Under Shade in Connecticut," *Bulletin* 137, New Haven, CT, February 1902.
101. Hendrickson, "New England Tobacco," 115.
102. "Tobacco Growers Tasting Sweet Success," *Hartford Courant*, Print, October 7, 1995.
103. McDonald, "Connecticut Tobacco Production," 21.
104. Thrall, "Our History," 2.

105. Hendrickson, "New England Tobacco," 143.
106. McDonald, "Connecticut Tobacco Production," 22.
107. Ramsey, *Tobacco Production*, 196.
108. Blake Harrison, "Mobility, Farmworkers, and Connecticut's Tobacco Valley, 1900–1950," *Journal of Historical Geography* 30, Elsevier Ltd., 4.
109. Ibid., 6.
110. Stacey Close, "Black Southern Migration and the Transformation of Connecticut, 1917–1941," *African American History Explored* (Middletown, CT: Wesleyan University Press, 2013), 240.
111. Harrison, "Mobility, Farmworkers," 6.
112. Cigar History.com, "History," http://cigarhistory.info/Cigar_History/History_1878-1915.html.
113. Patricia Cooper, *Once a Cigar Maker: Men, Women, and Work Culture in American Cigar Factories, 1900–1919* (Chicago: University of Illinois Press, 1992), 43.
114. F.D. Graves, "About Us," http://www.fdgrave.com/OURHistory.html.
115. Cooper, *Cigar Maker*, 7.
116. Ibid.
117. "200 Colored Men and Women Come Here for Work," *Hartford Courant*, Print, June 15, 1916.
118. Close, "Black Southern Migration," 240.
119. Brianna Dunlap, "The Repeal of Public Law 78," Central Connecticut State University, 2014, 6.
120. Warren Griffen, "Oral History Interview of Donald R. Clark January 25, 1995," Oral History Collection, Lutwinas Memorial Library, The Connecticut Valley Tobacco Museum.
121. Close, "Black Southern Migration," 242.
122. Ibid., 262.
123. McDonald, "Connecticut Tobacco Production," 24.
124. Ramsey, *Tobacco Production*, 187.
125. Ibid., 189.
126. Ibid., 190.
127. U.S. Department of Agriculture, "Quick Stats Results," http://quickstats.nass.usda.gov/results/5F2884B3-0935-3C73-9752-BAED4CC547D5.
128. U.S. Department of Agriculture, "Quick Stats Results," http://quickstats.nass.usda.gov/results/3C068458-B107-3F6E-B8B6-F9B5789A1B3A.

129. Ramsey, *Tobacco Production*, 164, quoting *U.S. Tobacco Journal*, January 22, 1921.
130. Hendrickson, "New England Tobacco," 144.
131. McDonald, "Connecticut Tobacco Production," 27.
132. Ibid., 26.
133. Ibid.
134. Heimann, *Tobacco and Americans*, 236.
135. Daniel Howard, *A New History of Old Windsor* (Windsor Locks, CT: The Journal Press, 1935), 228.
136. Ibid., 227.
137. Harrison, "Mobility, Farmworkers," 1.
138. Ibid., 8.

Chapter 5

139. Steve Collins, "Picking Tobacco in Connecticut, Like King Did," *Bristol News* (January 21, 2013), http://bristolnews.blogspot.com/2013/01/picking-tobacco-in-connecticut-like.html.
140. Fay Clarke Johnson, *Soldiers of the Soil* (New York, NY: Vantage Press, 1995), 7.
141. U.S. Department of Agriculture, "Quick Stats Results," http://quickstats.nass.usda.gov/results/86049669-729F-39A3-9D94-3AF93BF8A904.
142. Jean Stubbs, "El Habano and the World It Has Shaped: Cuba, Connecticut, and Indonesia," *Cuban Studies*, no. 41 (2010): 52.
143. Johnson, *Soldiers of Soil*, 19.
144. Rebecca Sausner, "Author Traces Toil-Filled History of Jamaican Migrant Workers," *Hartford Courant*, December 16, 1995, http://articles.courant.com/1995-12-16/news/9512160550_1_farm-workers-jamaican-migrant-workers-workers-families.
145. Johnson, *Soldiers of Soil*, 35.
146. Ibid., 49.
147. Sausner, "Author Traces Toil-filled History."
148. Harrison, "Mobility, Farmworkers," 8.
149. Dow Diamond, "Tobacco Sewer in Magazine Ad: Symbol of America," December 1952.

150. Interviews with visitors to the Connecticut River Tobacco Museum by staff.
151. "NINE LITTLE GIRLS," *Hartford Courant*, July 19, 1945.
152. "Negro Girls Complain to Mortensen," *Hartford Courant*, July 19, 1945.
153. "Former CCC Camp Greets Work Army," *Hartford Courant*, April 26, 1943.
154. "1,000 Tobacco Harvest Workers Needed at Once," *Hartford Courant*, August 18, 1946.
155. Johnson, *Soldiers of Soil*, 64.
156. Collins, "Picking Tobacco."
157. "Co-Workers on Simsbury Farm Remember Martin Luther King Jr.," *Journal Inquirer*, July 1989.
158. Collins, "Picking Tobacco."
159. Ibid.
160. Hutchins, "Laboring in the Shade," *Connecticut History Explored*, 9, no. 3 (Summer 2011).
161. Linda Lamagdeleine-Poirier, "Summer Memories," *Chronique Americaine Online les Cliche*, 2008.
162. Hutchins, "Laboring in Shade."
163. U.S. Department of Agriculture, "Quick Stats Results," http://quickstats.nass.usda.gov/results/329051E4-3073-380C-B181-C751668D57FD.
164. U.S. Department of Agriculture, "Quick Stats Results," http://quickstats.nass.usda.gov/results/7048EA9D-080C-33D9-A125-63DE11B474C9.
165. Frank Atwood. "Farm News: Puerto Rican Labor," *Hartford Courant*, March 30, 1952: A9.
166. Mildred Savage, *Parrish* (New York, NY: Simon & Schuster, 1958).
167. Laura Cooper Rendina, *World of Their Own* (Boston, MA: Little Brown & Company, 1953).
168. Salim Lamrani, *The Economic War Against Cuba: A Historical and Legal Perspective on the U.S. Blockade* (New York: Monthly Review Press, 2013), 14.

Chapter 6

169. U.S. Department of Agriculture, "Connecticut 1965 Outlook for Agriculture," Booklet no. 65-05 (Storrs, CT: University of Connecticut), 17.
170. W. Willard Wirtz, *News from the U.S. Department of Labor, "For Release: Immediate Saturday, December 19, 1964"* (U.S. Department of Labor, 1964).
171. Ibid.

172. Irving Kravsow, "Probe into Farm Conditions Asked by Puerto Rican Center," *Hartford Courant*, Print, March 7, 1959, 1.
173. Ibid.
174. Ruth Glaser, "Tobacco Valley: Puerto Rican Workers in Connecticut," *Hog River Journal* 1, no. 1 (Connecticut Explored, Fall 2012). http://www.hogriver.org/issues/v01n01/tobacco_valley.htm.
175. Rosner & Markowitz, "Introduction: Workers' Health and Safety—Some Historical Notes," *Dying for Work* (Indianapolis, IN: Indiana University Press, 1987), xviii.
176. U.S. Department of Agriculture, "Connecticut 1965 Outlook," 16.
177. Margaret Buker Jay, "Changing Landscape Through People: Connecticut Valley Tobacco," Edward King Museum of Aviation and Tobacco (East Hartford, CT: CT Humanities, 1982.)
178. Ibid.

Chapter 7

179. "Made in the Shade Cigar Craze Putting Tobacco Back in the Valley," *Hartford Courant*, Print, April 27, 1997, A1.
180. Ibid.
181. "Tobacco Growers Tasting Sweet Success," *Hartford Courant*, Print, October 7, 1995.
182. Ibid.
183. Ibid.
184. Jim Motavelli, "Cigar Smoking Is Dangerous to Human Health," *Smoking: Current Controversies* (San Diego, CA: GreenHaven Press, 2002).
185. Kimberly Reeger, "Women and Cigars," E-mail to B. Dunlap, March 2016.

Chapter 8

186. Matthew Rosen, "Ten Things to Know About Cigar Wrappers," Blog Critics (June 1, 2005), http://blogcritics.org/the-ten-things-to-know-about.
187. U.S. 2012 Census of Agriculture, "Race Ethnicity and Gender Profile," Online Resources. https://www.agcensus.usda.gov/Publications/2012/Online_Resources/Race,_Ethnicity_and_Gender_Profiles/Connecticut/cpd09000.pdf.
188. Glaser, "Outstanding Resource Values," 19–28.

189. Michael Duke, "Ethnicity, Well-Being, and the Organization of Labor among Shade Tobacco Workers," *Medical Anthropology* 30, no. 4 (July 2011): 409–424.
190. Ibid.
191. Ibid.
192. David Savona and Gregory Mottola, "Storm Touches Down in Connecticut Tobacco Country," *Cigar Aficionado* (July 1, 2013), http://www.cigaraficionado.com/webfeatures/show/id/17150.
193. Savona, "Major Changes to U.S.-Cuba Relations," *Cigar Aficionado* (December 17, 2014). http://www.cigaraficionado.com/webfeatures/show/id/Major-Changes-to-US-Cuba-Relations-17916.
194. Lamrani, *Economic War*, 8.
195. Savona, "Major Changes."
196. Mimi Whitefield, "New Cuba Regulations Provide More 'Wiggle Room' for U.S. Businesses," *Miami Herald*, January 27, 2016. http://www.miamiherald.com/news/business/international-business/article56925143.html.
197. Connecticut Legislative Aides, "Inquiry into How Many Acres and Pounds Were Produced in the State," E-mail to the Connecticut Valley Tobacco Museum, Spring 2015.
198. U.S. Food and Drug Administration, "Deeming—Extending Authorities to Additional Tobacco Products," Tobacco Products and Regulations. Last updated October 13, 2015.
199. "Going After a Good Cigar: The FDA Wants to Expand Its Authority to Regulate Premium Pleasure," *Washington Times*, Editorial, http://www.washingtontimes.com/news/2015/may/3/editorial-fda-attempts-to-regulate-premium-cigars/.
200. Congress, "Economic Development Revitalization Act of 2011," Senate Amendment Proposed by Senator McCain. https://www.congress.gov/amendment/112th-congress/senate-amendment/441/text.
2010. Marcia Trapé-Cardoso, et al., "Cotinine Levels and Green Tobacco Sickness Among Shade Tobacco Workers," *Journal of Agromedicine* 10, no. 2 (2005): 27–37. http://www.tandfonline.com/doi/abs/10.1300/J096v10n02_05.
202. "Picking Tobacco Can Be Hazardous to Their Health: Young Workers Exposed to Nicotine Poisoning—Although Connecticut's Shade Tobacco an Exception," *Hartford Courant*, Editorial, May 20, 2014.

203. Trapé-Cardoso, "Latent Tuberculosis among Latino Migrant Farmworkers in Connecticut," *Connecticut Medicine* 72, no. 7 (August 2008): 405–409.
204. Glaser, "Outstanding Resource Values," 19–28.

CHAPTER 9

205. Harrison, "Mobility, Farmworkers," 11.
206. Glaser, "Brook Management Plan," 57.
207. http://www.massland.org/about-coalition.
208. http://cttrust.org/cttrust/page/historic-designations.
209. http://www.ctconservation.org/aboutus.
210. Glaser, " Brook Management Plan," 71.
211. Ibid.
212. Ibid.
213. Colin McEnroe, Betsy Kaplan and Chion Wolf, "Connecticut Grown Tobacco," Dale Cahill, October 28, 2014, http://wnpr.org/post/connecticut-grown-tobacco#stream/0.
214. J.F. O'Gorman. "Hung Out to Dry?," *Hartford Courant*, September 17, 2006, http://articles.courant.com/2006-09-17/news/0609170242_1_sheds-frank-lloyd-wright-tobacco.
215. "Tobacco," *Connecticut Circle*, Vol. 6, 1948.
216. Buker, "Changing Landscape," 9.

INDEX

A

African Americans 48, 51, 53
Africans 20, 21

B

Broadleaf 33, 34, 35, 36, 42, 45, 48, 53, 77, 84, 87, 88, 90, 92, 96

C

child labor 47, 48, 62, 64, 67
cigar
 anatomy 33
 factories 31, 50
 manufacturing 31, 34, 35, 47, 50, 84, 92, 100
civil rights 67, 69
Civil War 29, 33, 35, 36, 37, 50
Colonial New England 20, 22, 24, 26
Columbus 16
Connecticut Shade leaf 42, 43, 57, 71, 90, 92, 96, 97, 99, 101, 102
Cuba 27, 31, 35, 59, 76, 77, 99, 100
Cuban cigars 27, 30, 31, 93, 100
Cuban tobacco 22, 33, 42

E

Early Woodland Period 15, 16
England 17, 20, 21
experimental station 45, 55, 56, 97, 109

F

fertilizer 34, 39, 40, 55

H

Havana leaf 36, 37, 41, 45, 48, 88, 96
health
 nicotine 89
 work standards 85
hurricane of 1938 59

I

immigrants
 children of 47
 Jamaican, West Indian 61, 63, 64, 67, 81, 82, 98
 Mexican 77, 78, 79, 98, 99
 Polish 36
 Puerto Rican 61, 80, 81, 82, 84, 98

Index

K

King, Martin Luther, Jr. 69

M

Massachusetts 16, 20, 22, 24, 27, 31, 34, 35, 36, 55, 61, 70, 106, 107

N

Native Americans 15, 16, 17, 18, 22, 24, 26, 30
New Hampshire 16, 36
Nicotiana rustica 15, 16, 22, 33, 104

P

Pequot 16, 22
Pocahontas 21
Prout, Sally 11, 30, 31
Public Law 78 77
Putnam, Israel 11, 26, 30

S

sheds
 early construction of 39
 preservation of 106, 108
 use of 35, 42
Sumatran leaf 37, 41, 42, 43

T

tornado of 2013 99

U

unions 50, 53

V

Vermont 16, 36
Virginia 20, 21, 22, 23, 24, 25, 35

W

Windsor 22, 25, 30, 31, 34, 36, 41, 55

women
 African American in cigar factories 53
 colonial 21, 31
 during World War II 61, 64, 67
 in cigar factories 47, 50
 smoking cigars 35, 95, 96

Y

Yankee 29, 30, 31

ABOUT THE AUTHOR

Brianna E. Dunlap is a museum professional who has been with the Connecticut Valley Tobacco Museum in Windsor, Connecticut, since June 2013. Besides working for the museum, she is finishing her last year as a graduate student in public history at Central Connecticut State University. When she is not working or studying, she enjoys two conflicting interests: running and a love of chocolate.

*Visit us at
www.historypress.net*

This title is also available as an e-book